LOST
BIRMINGHAM

BEVERLY CRIDER

Charleston London

THE
History
PRESS

Published by The History Press
Charleston, SC 29403
www.historypress.net

Copyright © 2013 by Beverly Crider
All rights reserved

Cover image courtesy of Tim Hollis.

First published 2013

Manufactured in the United States

ISBN 978.1.60949.988.4

Library of Congress CIP data applied for.

CONTENTS

Contents

FOREWORD

Lately, it seems that just about any book concerning Birmingham's pop culture history has either an introduction or a foreword by me—so yes, folks, here I am once again to usher you into the weird, wonderful, sometimes murky and always fascinating world of *Lost Birmingham*.

Just what does "lost Birmingham" mean, you ask? Well, as you will find when scanning the twenty different topics covered in this book, it can mean many different things. Some of the sites covered herein truly are—like Huckleberry Hound's girlfriend, Clementine—"lost and gone forever." Those would include the O'Brien Opera House, the Caldwell Hotel and, of course, the late, lamented Terminal Station. (As an aside, I was asked not long ago how the people of Birmingham could have allowed the demolition of such a magnificent structure. I explained that in 1969 there wasn't really the sense of historic preservation that exists today. In fact, it was not until the mid-1980s, when Cecil Whitmire's campaign to save the Alabama Theatre went into full swing, that the fate of the Terminal Station began to be thrown up over and over again as a specter of what could happen. It worked for the Alabama, and since then, the Terminal Station has become the ghostly poster child for any number of preservation efforts.)

Getting back to the subject at hand, a site does not actually have to be extinct to be considered "lost" in this book. Take the case of the landmark detailed in the ninth chapter, the Thomas Jefferson Hotel (aka the Cabana, if you are slightly younger). That hulking edifice is very much still with us, but in its current condition, it is in even worse shape than the Terminal

Station was when the wrecking ball began to swing. Ditto for the Quinlan Castle, that mysterious-looking relic on the slope of Red Mountain that looks like it was transported to Birmingham from the world of King Arthur (or Harry Potter, again, depending on how old you are). Although the Quinlan is presently an empty shell, it came awfully close to not even existing in that form, so there is reason to celebrate even with that.

The Lyric Theatre, catty-cornered across Third Avenue North from the Alabama Theatre, falls somewhat between the condition of the Thomas Jefferson and Quinlan Castle. While suffering from years of neglect—even its 1970s and 1980s days as a porno house did not help it keep in shape—the Lyric is far from being empty. I remember when Cecil Whitmire and his loyal minions first acquired the Lyric, and he took me inside. Broken seats were everywhere, but Cecil was ecstatic because they had just removed part of the ugly drop ceiling in the former lobby area—which had most recently served as a beauty supply store—and the original 1914 ceiling work and light fixtures had been discovered still intact. Any building with that much resolve to hang in there deserves all the loving attention it can get.

And so, as I usually do, I now leave you in the capable hands of Beverly Crider, who will be your tour guide for the rest of the way. I'll be lurking in the back of the group, though, looking forward to exploring these lost and not-so-lost sites along with the rest of you. Onward, brave souls!

Tim Hollis
www.birminghamrewound.com

PREFACE

Time has no mercy. The wrecker's battering ball is always eager. Fire is indiscriminate. And together they have taken a sad and heavy toll of structures which were once social landmarks, many of which grew up with the city and some of which are etched forever on the image of a younger, vanished Birmingham.
—Birmingham News, *December 19, 1971*

I grew up in Birmingham, yet I missed out on much of our history. I'm not old enough to have seen the Thomas Jefferson Hotel in its glory or viewed a play at the Lyric Theatre. I would have loved to have met Miss Fancy in Avondale Park, but yet again, I hadn't been born yet. I was just a small child when the Terminal Building met the wrecking ball, and while I did see movies in the Alabama Theatre as a child, I would have loved to have seen it "back in the day!"

To be honest with you, I took for granted the landmarks I did see growing up. I visited the top of *Vulcan* one time and just accepted that the largest cast-iron statue in the world would always be there to greet me atop Red Mountain. Amazingly, I never even noticed the zeppelin mooring station on top of what by then was called the Cabana Hotel. When I worked downtown, I must have walked or driven past the buildings of Birmingham's original skyline hundreds of times, yet didn't acknowledge their contributions to our city's development.

The "Heaviest Corner on Earth"? Never heard of it. Hillman Hospital? Sure, I knew that it was part of the University of Alabama at Birmingham

(UAB) Medical Center. I even worked in the media relations office at the university, yet I never really thought about what Birmingham was like—what the skyline looked like when that little building, by today's standards, stood there alone without the massive medical center surrounding it. I never really thought about the important role it played in the health and well-being of our Founding Fathers (and Mothers).

Needless to say, I've learned more about the Magic City while writing this book than I ever did while growing up in the city. It's given me a greater love and respect for Birmingham and made me extremely sad about the loss of so many beautiful landmarks—many of which I never had the opportunity to see.

I've also got to say a big "thank you" to my husband, Kyle, who started me on this journey of exploration. I've always been interested in history to some degree, but it was Kyle who introduced me to the "strange" side of history. Together, we started a Facebook page called "Strange Alabama" a few years ago. The page focuses on the state's curious and forgotten lore, interesting facts about Alabama history, cool and unusual places to visit, regional ghost stories and more.

The Facebook page led to writing a blog on Alabama's leading news site, AL.com. That, in turn, led to my introduction to Chad Rhoad at The History Press. And the rest, as they say…no, I won't go there.

LAKEVIEW PARK

Site of the First Alabama-Auburn Football Game

Situated in the center of the most fashionable suburb of Birmingham, Lakeview was the greatest and crowning development of aristocracy of the Highlands. Lakeview Hotel, together with the magnificent park and grounds, was known far and wide for its hospitality.
–Historic Alabama Hotels & Resorts

On January 26, 1871, a group of businessmen gathered at the office of Josiah Morris and Company in Montgomery to officially organize the Elyton Land Company. There, the board of directors adopted bylaws, among which was the following: "The city to be built by the Elyton Land Company, near Elyton, in the County of Jefferson, State of Alabama, shall be called Birmingham."

Among the improvements by the Elyton Land Company, after the city was established, were Highland Avenue and Lakeview Park, a park in the Lakeview suburb of Birmingham, located at the intersection of Highland and Clairmont Avenues. The park was formed around a man-made lake that was created by damming up springs in the area. It was accessible by the streetcar system running along Highland Avenue. Streetcars brought tremendous changes to the everyday lives of Americans in the late 1800s. They encouraged the growth of suburbs by allowing people to live miles from where they worked. They also opened new avenues for amusement that led to the development of Birmingham's turn-of-the-century lake resorts.

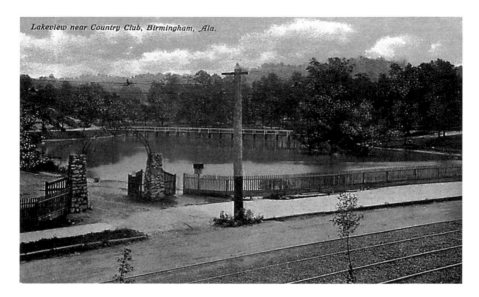

Lakeview Park circa 1911. *Post Card Exchange, Birmingham, Alabama.*

As part of the Lakeview Park development, the Elyton Land Company built the Lakeview Hotel, which was opened to the public on July 12, 1887, and was visited by Presidents Grover Cleveland and Benjamin Harrison. It became a rendezvous, especially during the summer months, for the elite of the city and of all parts of the South. It was as cool in the summer as any place in the region. The two-story building at first contained seventy-two rooms. Sixty additional rooms were added in 1888 in order to accommodate the crowds.

The entire building was lit by electric lights, and each room had running water and an electric bell. The building was heated by steam throughout. The cuisine of the Lakeview Hotel was known for its excellence, with French cooks serving only meats that were purchased in New York.

THE HAWES HORROR

During the second year of operation, the Lakeview Hotel and Park became entwined in a notorious murder mystery that became known as the "Hawes Horror."

Richard Hawes and his wife, Emma, reportedly an alcoholic, had a troubled marriage. Hawes often left his family alone in their home in Lakeview while running trains between Birmingham and Columbus, Mississippi, for Georgia-Pacific. Their oldest daughter, May, was left to care for her younger sister, Irene, and her little brother, Willie, with some help from Fannie Bryant, who did laundry and cooked for the family.

On December 4, 1888, the body of a young white female was found in East Lake by local teenagers out for a boat ride. Jefferson County coroner Alfred Babbitt conducted an initial exam on site and determined the cause of death to be murder. No one in the area, however, recognized the young girl. The body was laid out for viewing by the general public at Lockwood & Miller's Funeral Parlor in the hope that someone could identify her. Thousands viewed the body, but it wasn't until the next day that a local butcher recognized the deceased as May Hawes, daughter of Richard and Emma Hawes.

During the following inquest, confusion arose regarding the status of the Haweses' marriage. While many witnesses believed that Emma was Richard's wife, several witnesses swore that Richard was divorced and had left for Columbus, Mississippi, to marry again. Fannie Bryant stated that on the weekend before May's body was found, she saw Richard and May help Emma pack for a trip to Atlanta to retrieve their son, Willie, who was staying with Richard's family at the time.

After the inquest adjourned, the *Weekly Age-Herald* received a telegram announcing Hawes's marriage to the former Mayes Story in Mississippi that very afternoon. It also listed their train itinerary from Columbus, Mississippi, to Atlanta, Georgia. When the train made a stop at the Birmingham station, police officers boarded and arrested Hawes for murder.

In custody, Hawes pleaded his innocence and wrote letters to his new bride asking forgiveness for claiming to be a widower and not mentioning having a daughter. To police, he claimed that he had divorced Emma and arranged for the care of his daughters, although no record was ever found.

On Friday, December 7, during a long day of questioning, Mayes Story Hawes admitted that Richard told her he was divorced and had only one male child. In a letter he wrote to her from jail, Richard told her that he never mentioned May because she would be in a convent, and he did not want to trouble his new bride. Irene was never mentioned.

While Hawes's youngest child, Willie, continued to remain safely in Atlanta with Richard's brother, Jim, Birmingham police began searching for Emma and Irene. The discovery of a bloody hatchet and a torn ribbon

led investigators to Lakeview Park, where, on December 8, they dragged the lake, revealing Emma Hawes's bruised and beaten body, weighted down with iron.

After a riotous group of some two thousand marched on the city jail, outraged by the horror of these murders, a renewed effort was made to find Irene Hawes.

After repeated draggings of the lake turned up no body, the lake was drained. On the third day of draining, Irene's body was found about thirty feet from where her mother's was, also weighted down. Irene's body was taken to the Lakeview Park Pavilion for a cursory examination. Hoping to avoid another riot, Irene's body was taken from the pavilion directly to the city cemetery, where she was immediately interred. Apparently, the lake was refilled, as the *Baist Property Atlas*, which was published in 1902, shows a lake at that location. It is unclear when the lake was drained permanently; however, Highland Park Golf Course opened in 1903 on the location the lake previously occupied.

A report by Goldsmith B. West, "The Hawes Horror and Bloody Riot at Birmingham: A Truthful Story," was published in 1888, only weeks after the riots. "Perhaps before the story is finished it will appear that, in some of its aspects, criminal history during modern times can hardly furnish a case of parallel atrocity," he wrote.

He went on to describe the incongruity of the grisly murder compared with the idyllic setting of Lakeview:

> *To the outside reader it may be interesting to understand that Lakeview is to Birmingham what Central Park is to New York, or Druid Hill Park to Baltimore. The property of the Elyton Land Company, Lakeview has been improved and embellished to a point leaving little to be desired. A large artificial lake, with a flower-capped island in the centre, is only one among a number of attractions. Overlooking the water is a handsome hotel, while on the surrounding heights are a number of ornate cottages. A casino, with refreshment rooms, ball and billiard rooms, bowling alleys, and a huge swimming bath, occupies a prominent place by the shore. Altogether, Lakeview, with its facilities, and with its dummy line going all around among the fine residences of the mountain into town, is a place notable enough to attract attention in any community.*

The Hawes trial began on Monday, April 22, 1889, at the Jefferson County Courthouse. Although Hawes was charged with murdering all three

victims, the state decided that the strongest case was that of May's murder and structured the trial around it. Since there were no witnesses to the actual crime, the prosecution's case was built on circumstantial evidence.

Hawes's motive in murdering May, according to prosecutors, was to cover up any knowledge of his previous murder of her mother and younger sister. The prosecution maintained that Hawes needed to dispose of his wife and children in order to marry Story.

The jury deliberated for fifty-five minutes and decided on the death penalty. The defense submitted several appeals to the Alabama Supreme Court, but all were denied. During this time, a request from a St. Louis circus owner to display the caged murderer in his sideshow was rejected.

Emma, Irene and May Hawes are buried next to one another in unmarked graves at Oak Hill Cemetery. The image of little May floating dead in East Lake has left a lasting impression on the area. According to East Lake residents, there have been sightings of a little girl playing at the lake's edge, swimming or slipping below the water at dusk. Called the "Child of the Lake" or the "East Lake Mermaid," the apparition is attributed to May's spirit.

ENTERTAINMENT

Lakeview made headlines for more than scandals during its heyday, however. The Lakeview Theatre, a covered stage for open-air concerts and performances, opened in Lakeview Park in November 1890 with a performance by Mrs. General Tom Thumb and Her Japanese Troupe. The following summer, a performance of Gilbert and Sullivan's *H.M.S. Pinafore* was staged on a replica ship floating in the lake, which was surrounded by electric lights.

The resort's centerpiece was the Lakeview Pavilion, featuring a swimming pool in the basement beneath a dance floor, a skating rink and a bowling alley.

The park also was home to the Lakeview Baseball Park, which hosted a number of events. Arguably, the most important event that occurred at Lakeview Park, however, was not a baseball game but rather the first football game between the University of Alabama and the Agricultural and Mechanical College (Auburn University), which occurred on February 22, 1893.

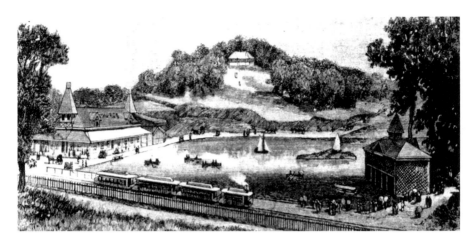

Above: Lakeview Park, with Highland Avenue and the Belt Railroad steam dummy visible in foreground, circa 1887.

Opposite, top: Team photo of the 1892 University of Alabama football team.

Opposite, bottom: Historical marker for site of first Alabama-Auburn football game. *Photo by Beverly Crider.*

At this time, touchdowns were scored as four points, with two points awarded for a successful kick after and five points for a field goal. Players wore no numbers or special protective equipment and played both sides of the ball for the entire game unless a substitute was brought in due to injury.

The face-off in Birmingham stirred excitement among supporters of both schools. Special trains from the respective campuses brought hundreds of cheering students and uniformed cadets to the city on the morning of the game. The University team (as it was generally called) used the Caldwell Hotel as its local headquarters, which was decorated with crimson and white for the occasion. The College team, also known as "the Auburns," set up at the Florence Hotel, which was similarly decorated in dark orange and blue. By noon, the streets were filled with lively crowds breaking out in the schools' respective yells.

By the advertised starting time of 3:00 p.m., the grandstands and boards surrounding the baseball park, newly striped for football, were filled to overflowing, and more fans pressed against ropes drawn tight around the rest of the field. The Auburns' supporters grouped together on the east side of the field, while University fans were scattered all around the park. Other spectators filled the surrounding hillsides.

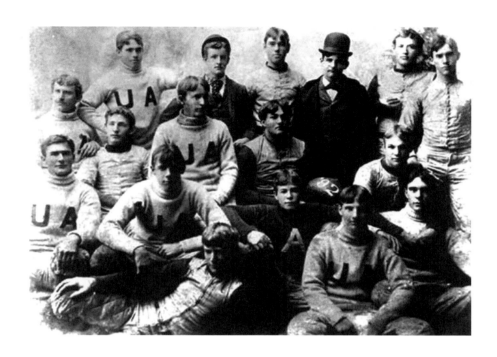

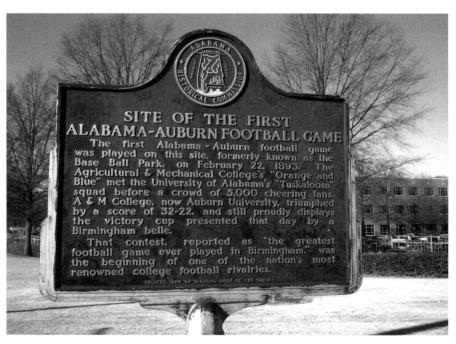

Many arrived in Lakeview by the Highland Avenue and Belt Railroad, which put several extra cars into service for the event. Others came by foot, by horseback or in buggies. One estimate of the attendance was five thousand people, and gate receipts were said to total $1,200 to $1,500.

The Auburns won the game, 32–22. This was the only game to be played at Lakeview, and the series did not return to Birmingham until 1902. The Caldwell Hotel prepared a special dinner for its guests from Tuskaloosa (as it was spelled then), featuring "Baked Kikoph Trout," "Right Guard Cornbread with Left Tackle Buttermilk," "Left Flank of Beef," "Braised Quarter Back of Tennessee Lamb" and "University Salad," followed by "One-Team-Out-in-the-Cold Sherbet." The special trains from Auburn and Tuskaloosa returned late that same night.

While the park was doing well, by 1891 it was obvious that the hotel was no longer able to compete with other resort hotels in the state. There were no mineral waters to interest the sick such as those found in places like Blount Springs. In fact, the Lakeview Hotel and Park was only intended to serve as a resort during the summer months. The hotel's doors closed for good on August 21, 1891.

Later that year, Dr. H.M. Caldwell, president of the Elyton Land Company, invited Hawthorne College of Florence to move to Birmingham and occupy the Lakeview Hotel building. The school became a ladies' seminary under the name of the Southern Female University. On December 6, 1893, the building burned down.

In 1900, the pavilion was torn down to build the Highland Park Golf Course. The Lakeview entertainment district retains the name of the park to this day. A section of the former baseball field was preserved as a grassy corner outside the BBVA Compass Bank administrative headquarters, with a historical marker describing the first Alabama-Auburn game.

EAST LAKE PARK AND MERMAID

*Old-timers tell of an active community life with hayrides, peddlers, livery stables,
trains from downtown every 45 minutes, concerts and literary programs at
Howard College and the Atheneum (a girls' academy), grocery wagons, band
concerts and other pleasures of turn-of-the-century life.*
—Birmingham Post-Herald, *1981*

Long before East Lake even had a lake, the community was a settlement
along Village Creek. It predates the 1871 incorporation of Birmingham,
with settlers forty years before the Civil War. The first school opened on
December 1, 1819, two weeks before Alabama became a state, at what would
become the corner of Fourth Avenue South and Oporto-Madrid Boulevard.

In 1886, the East Lake Land Company was formed to sell home sites to
men coming to work in Birmingham's steel industry. In 1887, the company
constructed a thirty-four-acre artificial lake on its property six miles from
downtown Birmingham and named it Lake Como after the lake in the
Italian Alps.

Water for the lake came from the springs at Roebuck. The completed
lake was 2,200 feet in length and averaged 800 feet in width. Depth ranged
from 4 to 14 feet. It didn't take long for East Lake Park to become a major
recreational location in the area. In 1887, a streetcar line was run from
Birmingham to the park.

Through the years, the park was home to a zoo, a Ferris wheel, a roller coaster,
a miniature railroad, a shooting gallery, a steamboat and an amusement ride

called the "Human Roulette Wheel" that featured giant cup-and-saucer seats. It was a favorite spot for fishing, boating, swimming, water skiing, golfing and playing baseball. At one time, the East Lake Zoo housed a bald eagle, a wolf, two pelicans, two deer, a groundhog, two raccoons, two white rabbits, a kangaroo, seven prairie dogs and a South American anteater.

In 1889, B.M. Boulden built a hotel on the border of the lake at the eastern end of the park at First Avenue and Eighty-third Street North, where the dummy line from Birmingham ended. The building was two hundred feet long and contained 150 rooms. The two-story hotel was built for about $20,000. Each floor had a porch covering three sides. A large dining room was adjacent to the main lobby. Since the East Lake area was elevated, many thought that it was an ideal location to avoid Birmingham's summer heat.

The six-mile distance from Birmingham proved to be too far to attract commercial guests, and competition with the Lakeview Hotel for summer business was too great. Boulden closed his East Lake Hotel after only one year of operation. He disposed of all the furnishings with the exception of one room, which he occupied himself. On June 10, 1891, the hotel completely burned down within three-quarters of an hour. A lightning strike to the building was blamed for the fire.

Boulden's room was located near where the fire originated, but he was not in the building. He had left the evening before, telling his neighbors that he was leaving for Pensacola, Florida, where he had interest in the street railroad. The site of the hotel was turned into a playground, a part of the municipally owned East Lake Park.

The City of Birmingham purchased the park in 1917. The city kept many of the park's attractions open during the next decades, while adding other recreational facilities. During the Great Depression, workers from the Civil Works Administration drained a swampy area north of the lake, regraded picnic and bathhouse areas and constructed three tennis courts and eleven barbecue pits.

East Lake was described in the 1920 work *Birmingham and Its Environs* as an amusement park of about sixty acres, with a large lake covering about twenty-five acres. "It is equipped with bath houses and a large pavilion built over the lake. It has many amusement devices such as a roller coaster, old mill, merry-go-round, whip and Ferris wheel, and many other attractions," it noted. "Fishing is good in the lake and there are about fifty boats on the lake. The park contains a well equipped playground and an ostrich and alligator farm, drinking fountains, band stands and many other things that go to make it an amusement and recreation grounds."

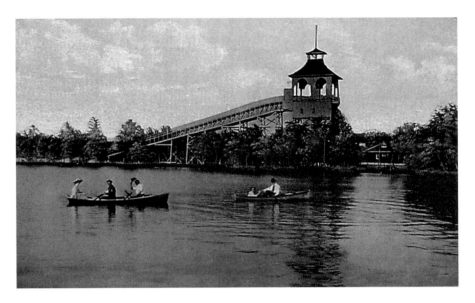

East Lake Park view of "Shooting the Chutes," circa 1909. *Post Card Exchange, Birmingham, Alabama.*

East Lake Park, 2013. *Photo by Beverly Crider.*

Perhaps one of the lake's most notorious events was the discovery of the body of eight-year-old May Hawes, found floating in the lake by two boaters on December 4, 1888. The little girl, who was later called the "Child of the Lake" and the "East Lake Mermaid," was murdered by her father, Richard Hawes. The murder investigation led to the discovery of her sister's and mother's bodies in Lakeview. Residents of the area began to report sightings of a little girl playing at the lake's edge, swimming or slipping below the water at dusk. They attributed the apparition to May's spirit.

The East Lake Arts District now holds an annual storytelling and memorial for May, whom locals call their "very own resident ghost." On the night before Halloween, guests light candles and jack-o'-lanterns and toss carnations into the water to "appease her spirit."

As one of Birmingham's first communities, East Lake was home to one of the area's first residents as well. Mrs. M.E. Pyle drove a wagon team into Jones Valley three years before the War Between the States, when downtown Birmingham was nothing more than a cornfield. She and her husband came here from Augusta, Georgia, in 1858, herding cattle and hogs before them.

An article in the *Birmingham Post* on August 3, 1935, described her journey in an announcement of her death at the age of ninety-six:

> *The pioneer woman, who remained healthy and hardy as she watched Jones Valley develop into a rugged, tough little mining town and finally into one of the South's biggest cities, became ill three weeks ago. Relatives said she had been in excellent health until then.*
>
> *Mrs. Pyle often told her children and grandchildren of driving into Jones Valley when Birmingham was only a big corn field and of pitching camp at Avondale Springs where they lived until they built a farm home on the site now occupied by Acmar Mines.*
>
> *At the outbreak of the War Between the States, the Confederacy, hard-pressed for fuel, turned its eyes toward the red hills of the Birmingham district. The first coal mine in this section was dug in Mrs. Pyle's corn field. A wagon mine was opened on property now being used by the Alabama Fuel & Iron Co., at Acmar.*
>
> *Mrs. Pyle liked to tell of how she rode on horseback or drove wagons to Montgomery to buy Winter supplies, and to buy the latest finery shipped up the Alabama River from the Gulf.*
>
> *Mrs. Pyle's husband, a Confederate soldier, died soon after the Battle of Richmond.*

*During reconstruction days, Mrs. Pyle often saw the "night Riders"
passing through this district to lend aid to South Alabama planters.*

East Lake also was home to one of about fifty churches organized before Alabama became a state on December 14, 1819. Ruhama Baptist Church, organized in March 1819, was the first known Baptist church in the Birmingham area.

When Howard College (now Samford University) moved north from Marion to East Lake in 1887, the church and college formed a close relationship. Many students attended church services at Ruhama, and graduation ceremonies were often held there. By the late 1940s, Howard's leaders had selected a site for a spacious new campus in Shades Valley, just south of Birmingham. The college moved to its present location in 1957.

East Lake Park underwent a renovation in 1972 that included widened sidewalks, repaired dam, new picnic shelters and new landscaping. Additional landscaping and new parking areas were completed in 1978, and the path around the lake was resurfaced with crushed stone in 1980. In 2012, the park was listed on the Appalachian Highlands Birding Trail.

BIRMINGHAM'S FIRST SCHOOL

[Powell School] *has the distinction of being the school upon which the foundation of the present public school system in Birmingham was built.*
—Birmingham News-Age Herald

In the days of Birmingham's first "little red schoolhouse," boys like Samuel L. Earle walked along country paths to attend lessons on the site where Powell School now stands, however worse for wear, on the corner of Twenty-fourth Street North and Sixth Avenue.

Earle, one of the school's first students, had a Confederate veteran for a teacher, swapped Nick Carter novels and learned words from a blue-back speller. He told the *Birmingham News-Age Herald* in 1928 about his memories of school during Birmingham's early years: "I remember how we'd play at pitching rocks and sticks into an old sink hole in the grove. We thought there was an underground river, under the town. We couldn't see the bottom of the sink hole. So we thought our sticks would come out over at old Elyton spring. That was the most adventurous thing we did at recess."

The new town of Birmingham seemed to be on its way to becoming a full-fledged city in 1871, when it was officially chartered by the Alabama legislature. But the next four years almost killed the dream of John Milner, the engineer and surveyor who first conceived of building a city at the central crossroad of the state's two main railroads.

A cholera epidemic swept through the town of 4,000 in 1873, killing 123 people. That was followed by a national economic depression one year later that

wiped out many of the successful businesses left. A few months later, a group of citizens decided that Birmingham needed a free public school in order to survive. They discussed their concerns with Colonel J.T. Terry, one of the people who helped hold the city together during the epidemic. Terry agreed with them.

The Elyton Land Company, which established the city of Birmingham, donated land for the school through its president, Colonel James R. Powell, known as the "Duke of Birmingham" for his founding role in the city. The location, now a part of downtown Birmingham, was then cause for complaint for being too far out in the country.

After he was elected as Birmingham's second mayor in 1873, Powell turned over his salary from that position ($1,330 per year) for the school's use, along with all fines collected through the Birmingham Police Court. At one point, so the legend goes, he even put up a suit of his clothes as collateral for another loan to help build the school. Construction on the building started on the Twenty-fourth Street site in 1874.

There were four rooms for 150 students when the school opened in April 1874. D.C.B. Connelly was principal, and Terry served on the board of trustees along with George Thomas and J.J. Jolly.

Fees of about $1.50 per year were charged initially to help pay down debts, but the amount was reduced gradually, and the "Free School" eventually dropped the fees altogether up through the eighth grade. It was the first school to let down economic barriers and allow any "white" student in. It would take nearly seventy-five years to let down its racial barriers. It remained the only public school in the city until 1883, at which time it was reorganized and renamed for Colonel Powell.

Dr. J.H. Phillips became the first superintendent, removing the school from the control of the mayor and aldermen. Dr. Phillips organized the primary, grammar and high school grades into the one building. He divided the school into grades and gave every student a number. Young Earle was given the number thirty-three. That number was used instead of his name.

The following year, the Birmingham Board of Education was created to take over school operations from the mayor and board of aldermen. Powell graduated its first senior class in 1885, with commencement exercises held at the O'Brien Opera House.

In 1886, the original school building was damaged by fire and declared unsafe. Plans were made for a new fifteen-classroom structure on the same site, and an adjoining fifty-foot lot was purchased. Students attended class in an exhibit hall in a nearby park until the new Powell School was completed in 1888. The new facility was considered "the

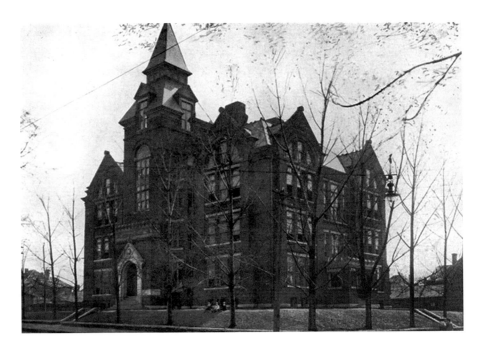

Powell School, 1908.

most modern and the best equipped elementary school in the South"
at the time. The brick exterior was crowned by a series of stone gables.
A central hexagonal room on each floor served as an office, while each
classroom had large triple windows on two sides.

In 1890, the high school students moved out of the Powell School and
met in the Enslen Building, located at 608 Twenty-first Street North,
the present site of the Tutwiler Hotel. The building served as the site
of Birmingham High School from 1890 to 1906. It also housed the
Birmingham Public Library when it was reorganized in 1891 under the
auspices of the Birmingham Board of Education.

Conducted in 1923 by the board of education, the School Building Survey
was less than flattering regarding the thirty-five-year-old facility that then
housed 667 students. "This building is one of the oldest in Birmingham,
and, therefore, of an obsolete type and not planned for present-day use," it
noted. "It is, however, in better condition than many of the later ones. It is
a pure class room school consisting of 12 rooms and is badly over-crowded.
The 18 square feet per pupil of playground space is inadequate but the city
park (East Park) in close proximity affords additional play space."

The study recommended adding two classrooms, a large gymnasium, a small auditorium, a kindergarten, a room for nature study, a music room, two home economic rooms, two manual training shops, a library and accessory rooms.

In 1941, following a fire at the Barker School, which was built in 1903, PTA president Harry Singler labeled Powell and Henley Schools as "firetraps" and suggested that the board tear them down and replace all three with a single, modern combined school in a central location. As the *Birmingham Post* noted on March 25, 1941, "As for the possibility of building a consolidated school in the area near Powell School, Mr. (Oliver) Steele was explosive: 'Downtown property isn't going to be worth a dime in a few years. It'll be just parking lots. Central City (in the Powell School area) is the ugliest thing in the world. That's just a warehouse district. Children can't cross Eighth-av on account of the heavy traffic.'"

With $10,000 from a $7 million bond issue passed in November 1945, a 50- by 190-foot lot adjacent to the school was purchased. Another 50-foot lot had already been acquired. The addition—housing a lunchroom, an auditorium and a boiler, as well as classroom space for fifty-two additional pupils—was completed in 1951. At the same time, the stairways in the older building were fireproofed and the lighting modernized. The cost was estimated at about $120,000.

Birmingham's first classes for vision-impaired students were pioneered at Powell School. Students spent part of the day working with their own teachers in a dedicated resource room and would join their sighted classmates for the remainder of the day, reading from braille editions of the same texts.

In the 1960s, the old building, which was showing obvious signs of disrepair, was at risk for demolition. Preservationists persevered, however, and in the summer of 1969, the brick exterior was sandblasted and the joints "rechinked" with new white mortar. A 1969 *Birmingham Post-Herald* article noted, "Visitors can marvel at the hexagonally-shaped office and at tall, wide windows on two walls of the classrooms. Antique furniture abounds in the old building, and classic staircases have wooden fixtures to prevent youngsters from sliding down bannisters."

In 1974, the building's future was again in question. The route of Red Mountain Expressway stood to wipe out the main residential sections that were served by Powell. Several groups and individuals didn't want to see that happen. "I think we've had about enough of this destroying historical sites and buildings in our city," said Gordon L. Starr, Powell principal since 1962. "Surely we can find some use for this old building to preserve the significant role it has played in the rise of Birmingham to major city status."

In 1976, Powell School was added to the National Register of Historic Places. In 1980, students of the school were moved to nearby Phillips High School at 2316 Seventh Avenue North after new cracks appeared in the plaster walls, and there seemed to be some softening of mortar between bricks in the school's basement, a sign of possible foundation damage.

The school board authorized an architect and two engineers to look at the school and assess the damage. Bettye Collins, school board president at the time, said that unless Powell School could be repaired to the degree that it was safe for children, "without an exorbitant amount of money being spent to do it," the board "shouldn't fool with it." Quoted in the November 30, 1980 *Birmingham News*, she added, "Our role is not to preserve history. Our role is to educate children."

A number of people disagreed with Collins's position, including Penelope Cunningham, program specialist with the board of education in 1980. "So many people went to Powell who helped make Birmingham, that Powell will always be loved."

Powell School closed in 2001 and was used for some time as a teaching laboratory. Students resumed classes in the fall of 2002 in a renovated section of nearby Phillips High School. Although the city had made proposals to redevelop the property for educational purposes, the 16,944-square-foot building was still vacant when it caught fire on the evening of January 7, 2011. The fire resulted in the roof and upper floor collapsing into the building. An analysis of the structural condition of the school was begun shortly afterward, with some hope being held out that the exterior shell could be stabilized. Following the fire, it was found that the board of education no longer carried insurance on the building and that the city's policy would provide only $350,000 toward repairs.

In February, an insurance inspector informed the city that the building was not structurally sound enough to be saved. In May, the city council gave the Alabama Trust for Historic Preservation six months to come up with a viable plan to save the building. The trust placed the structure on its 2011 "Places in Peril" list and contracted Meredith Environmental of Sylvan Springs to perform a preliminary stabilization and environmental assessment. KPS Group and Hoar Construction volunteered to donate services for studying "potential adaptive re-use of the structure."

In October 2012, the Birmingham Design Review Committee approved plans to erect a new roof on the fire-gutted Powell School and board up its windows to help preserve the 124-year-old building while negotiations with potential development partners continued.

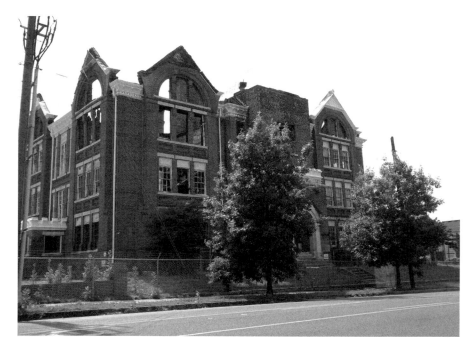

Powell School, 2012. *Photo by Beverly Crider.*

Michael Calvert, former president of Operation New Birmingham, is a volunteer project manager with the Alabama Trust on the possible restoration effort. "The exterior walls are in remarkably good shape and more of the interior features remain than we had originally anticipated," he said. Calvert added that the three-story building has the potential to become condominiums, apartments or offices, among other possible uses. But first, the building needs to be secured and shielded from the elements. "We are open to anything that saves the building," he said.

More than a century ago, Colonel James Powell described Birmingham as the "Magic City." Hopefully, a little of that magic continues to surround the school that bears his name. Birmingham can't afford to lose yet another of its irreplaceable landmarks.

*Mr. Nabers ha
who enjoys*

–Jefferson County and Birmingham, Alabama:
Historical and Biographical *(1887)*

THE FIRST HOUSE IN BIRMINGHAM

Anyone passing the southeast corner of First Avenue and Twenty-first Street North might admire the four-story Romanesque-style red brick building located there, but few will realize that they are passing the site of Birmingham's first house.

Constructed in 1869, the wood-frame structure with split board siding and roofing owned by William Nabers was used as a meeting place during the surveying and staking of the city's streets and lots. The building was never actually a residence, but a photograph of the picturesque wood shack on desolate ground, with wagon wheels and a ladder propped up on the outside walls, was widely reproduced with captions identifying it as the "first house built in Birmingham."

Nabers, who sold the original parcel on which the city was built to the Elyton Land Company, became a shareholder in the venture and retained

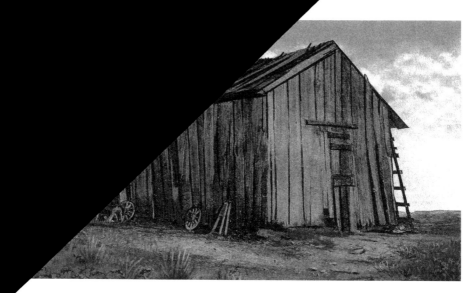

The William Nabers Shop, constructed in 1869 on what became First Avenue North near the southeast corner of its intersection with Twenty-first Street after the city of Birmingham was platted. The building was never a residence, but a photograph of the picturesque wood shack was widely reproduced with captions identifying it as the "first house built in Birmingham." *Faulkner's Novelty Company, Birmingham, Alabama.*

many choice lots, from which he earned an income. He reserved two acres in what is now the Southside, called "Nabers Grove," on which his house was standing and on which he built the Crystal Palace amusement park.

On February 5, 1867, he married Virginia Elizabeth Worthington, the daughter of Benjamin Pinckney Worthington, another original stockholder of the Elyton Land Company. Nabers died on November 15, 1918. He had six children.

John Witherspoon DuBose wrote the following in the book *Jefferson County and Birmingham, Alabama*:

> *In the Center of Nabers' Grove on the South Side, surrounded by gigantic oaks that breasted the storms ere the grandfathers of the men who made Birmingham saw the light of day, rests the comfortable home of Wm. F. Nabers, Esq. Upon the broad verandas that encircle this home of old-fashioned Southern style sat, many a summer night, Colonel Jamer. R. Powell, John T. Milner, Major Thomas Peters, and other pioneer spirits, who there, in quiet seclusion, with no roar of the furnace or rush of the train to disturb them,*

and no sound to break the hush except the rustle of the leaves, talked over their schemes and devised the methods to make Birmingham the great city that it is to-day. The home of Mr. Nabers at that time was the only house near the site of Birmingham, and beneath its hospitable shelter these bold forerunners of progress found a cordial welcome. Now this once secluded homestead is surrounded by houses, the Highland Avenue trains run by the door, and the city stretches far away on either side.

The Nabers' cabin survived and was reused as a wagon wheel works and a blacksmith shop by the Abel family. The Louisville & Nashville Railroad made brief use of it in 1887 as a toolshed before it was sold to Z.T. Partain, who also operated a smithy.

THE FIRST BOY BORN IN BIRMINGHAM

Shortly after Birmingham was founded, Patrick McAnally was recruited from Chattanooga by Colonel James R. Powell. McAnally, a lime burner and engineer, examined the limestone available on Red Mountain and designed and constructed a limekiln to produce quicklime. The lime was used in the creation of Birmingham's first buildings.

Soon after his arrival in the city, McAnally heard that Powell, president of the land company, was advertising that his firm would give the first white male child born in Birmingham a tract of land. He sent word to his pregnant wife in Chattanooga, but she told him that she was too ill to travel. McAnally returned to Chattanooga, saw to her recovery and brought her back to Birmingham by carriage.

Unable to purchase a house, he had to build his own. In the meantime, he and his wife lived in his workshop on First Avenue North and Twenty-third Street. There, Mrs. McAnally gave birth to a boy, Richard Powell, on November 11, 1871. The boy was, in fact, the first white male child born in the city.

The birth created quite a bit of excitement, and hundreds of settlers came to see the boy. Colonel Powell was in Montgomery at the time, and he received the news by wire. He wired back, "Let McAnally have the lot." The lot in question was located at First Avenue North near Twenty-second Street. McAnally also gave his son a half block on Sixth Avenue North between Thirtieth and Thirty-first Streets.

The child was baptized Richard Powell McAnally in St. Paul's Catholic Church. Known as "Birmy" to his friends, he lived in Birmingham all of his life. An attorney, he was a member of the city council in 1899. He is buried at Oak Hill Cemetery.

THE STEINER BROTHERS BANK

The Steiner Brothers Bank purchased the Nabers house and its twenty-five-by one-hundred-foot lot on January 15, 1890, for $21,760, demolished the cabin and began construction of the Steiner Building. These two brothers, Sigfried and Burghard, would soon play a role in bringing the young city of Birmingham through the economic panic of 1893.

Their so-called Steiner Plan proposed to have the city's interest on municipal bonds underwritten by the bank and then deferred for five years.

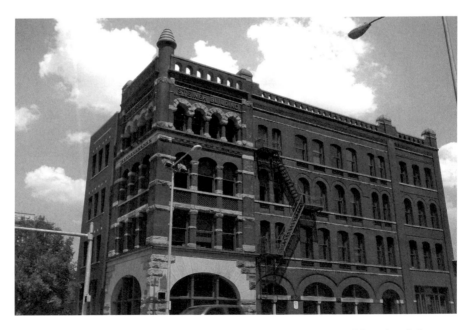

Steiner Building, 2012, constructed on the twenty-five- by one-hundred-foot site of the William Nabers cabin, considered to be the first house built within the original limits of Birmingham. *Photo by Beverly Crider.*

Sigfried personally visited bondholders to explain the plan. He bought back the bonds of anyone who doubted the city's ability to return the interest. The plan was a success, and the city was eventually able to pay its interest. Other cities in financial trouble have adopted similar plans based on the Steiners' model.

The Steiner Brothers Bank was relocated to Third Avenue North in 1963. After it moved out, the building was mostly vacant, at one point housing the offices of the Jefferson County Historical Society. The Steiner Building was added to the National Register of Historic Places on July 25, 1974.

O'BRIEN OPERA HOUSE

The O'Brien Opera House on the corner of First Ave. and 19th St. appeared to be outside the limit of the city. The Relay House had the ticket keeper's office and a room or two over it. A tin bowl and dipper was outside on the porch for anyone to wash. Where the Morris Hotel now stands was a big frog pond (lots of croaking).
—James Bowron Jr., upon his first visit to Birmingham in 1883

In 1878, Frank O'Brien—future Jefferson County sheriff and Birmingham mayor—bought 125 feet of frontage at the northwest corner of First Avenue North and Nineteenth Street. The location was then occupied by a sawmill operated by Thomas Jeffers and George Thomas. O'Brien paid what was then considered an exorbitant sum of $500.

Construction of his palatial four-story brick theater building began in May 1882 and was completed that November. He purchased brick from T.M.D. Erhart's yard south of Bessemer and lumber from a yard at Avenue A and Seventeenth Street. In addition to the second-floor auditorium—forty-nine feet from side to side, with a thirty-six-foot-deep stage opening to a twenty-eight-and-a-half-foot-wide proscenium—the building housed a hotel and ground-floor shops such as George Pappa's saloon and the Dunnam Brothers grocery store. The 1,266-seat theater used gas burners, incandescent lights and arc lights.

The theater opened with a sold-out performance of the controversial musical *The Black Crook*, staged on November 14, 1882, by the Huntley, Blaisdell and Brown Company. Considered a prototype of the modern musical in that its popular songs and dances are interspersed throughout a

unifying play and performed by the actors, it had proved controversial when it played in New York. Sermons were preached against it. As John Kenrick noted in *History of the Musical Stage 1860s: The Black Crook*:

> The Black Crook's *tortured plot stole elements from Goethe's* Faust, *Weber's* Der Freischutz, *and several other well-known works. It told the story of evil Count Wolfenstein, who tries to win the affection of the lovely villager Amina by placing her boyfriend Rodolphe in the clutches of Hertzog, a nasty crook-backed master of black magic (hence the show's title). The ancient Hertzog stays alive by providing the Devil (Zamiel, "The Arch Fiend") with a fresh soul every New Year's Eve.*
>
> *There were dazzling special effects, including a "transformation scene" that mechanically converted a rocky grotto into a fairyland throne room in full view of the audience. But the show's key draw was its underdressed female dancing chorus, choreographed in semi-classical style by David Costa. Imagine (if you dare) a hundred fleshy ballerinas in skin-colored tights singing "The March of the Amazons" while prancing about in a moonlit grotto. It sounds laughable now, but this display was the most provocative thing on any respectable stage. The troupe's prima ballerina, Marie Bonfanti, became the toast of New York.*

Opening night was eventful for another reason as well: the lights would not come on. Captain O'Brien borrowed headlights from locomotives from the nearby train yard.

A number of notable acts continued to cross the stage of the O'Brien throughout the late nineteenth century. Augustus Thomas's critically acclaimed *Alabama* made its debut in the opera house in 1891. The following year, Henry Mapleson's Opera Company of London staged *Fadette* there. The opera theater also hosted some of the greatest acts of that time, including Joseph Jefferson, Edwin Forrest, Roger Busfield, Rose Coglan, the Thatcher Primrose and West Minstrels and the New York Symphony Orchestra. The Deshon Opera Company were residents at the opera house during the 1893 season, and Sam T. Jack's Creole Burlesque Company caused a sensation that October with its primarily African American cast.

The opera house served as a meeting place for many groups. The Birmingham Chamber of Commerce was organized at the O'Brien on May 14, 1887. The Sunday School Board of the Southern Baptist Convention was created during a conference at the O'Brien on May 11, 1891. Also, the students of the first graduating class in Birmingham public schools received their diplomas at the opera house.

In 1895, Charles Whelan purchased the theater at a mortgage sale. He retained longtime manager Ben Theiss and music director Fred Grambs and enlarged the stage. In December 1898, Whelan's death led to another sale. A.L. Fulenwider and Henry Badham purchased it from his estate for $60,000 and began a major overhaul, which included lowering the stage to the ground floor and remodeling the hotel. Theiss and Grambs were retained as lessees. Fulenwider and Badham, in turn, sold the theater on March 28, 1899, to Joseph R. Smith Jr. and Charles J. Smith for $75,000.

In 1899, a New York company, Klaw and Erlanger, leased the theater for five years for $4,000. The story attracted attention because New Yorkers were taking interest in Birmingham's new theater life; even the *New York Times* reported on it.

The O'Brien Opera House attracted large crowds from all parts of the young city until 1900, when the larger and more beautiful Jefferson Theatre opened a few blocks away. Many of the vaudeville shows and group meetings that would have played the O'Brien moved to the newer hall. In 1905, the Columbia Amusement Company secured a lease on the theater and installed huge electrified signs across First Avenue North and Nineteenth Street to advertise its newly renamed Gayety Theatre. Manager E.A. McArdle circumvented the city's new ordinance against burlesque entertainments simply by not using that word in his advertising.

Nevertheless, on January 5, 1909, Birmingham police detective George Bodeker issued a formal warning: "I like to see a good show and enjoy it, but at the same time I will not tolerate any such movements as I saw this afternoon and I assure you that if this occurs tonight, I will most assuredly put the entire troupe under bond." Under increased scrutiny, the theater closed on April 17 of that year.

After a brief run as a burlesque house, the Gayety was opened once again as the O'Brien Opera House. The next season, it changed its name to the Virginia. The Shubert Organization acquired the lease in 1910, renaming the hall the Shubert Theater. The new managers were so successful that they occassionally had to lease the larger Orpheum Theater for programs such as Bessie Abott's performance in Puccini's *La Bohème*. Despite the theater's new success with "legitimate" theater, the Birmingham fire chief declared the building unsafe on May 31, 1911. It was never reopened and was finally torn down in 1915, just when theater was beginning to flourish in Birmingham. Another edifice was built in its place using some of the original bricks, but that building was demolished as well.

A marker, donated by O'Brien's daughter, Bossie, and then property owner Ellen Hickman, was erected on the site of the former opera house in 1950.

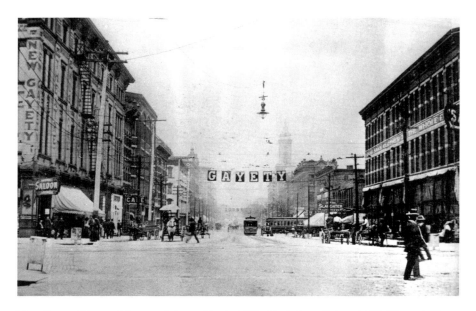

New Gayety Theatre, Nineteenth Street North, 1908. *Birmingham, Alabama Public Library Archives.*

Bossie O'Brien Hundley Baer was a leading lobbyist for women's suffrage in Birmingham. In 1886, the Birmingham Fire Department's newest steam engine was nicknamed the "Bossie O'Brien" in her honor. She married state legislator and district court judge Oscar Hundley on June 24, 1897.

Hundley joined the Birmingham Equal Suffrage Association soon after it was formed in 1911 and quickly rose to a position of leadership in the group. She became president of the Birmingham chapter and then legislative chair of the statewide association. In 1914, she organized a petition drive that collected more than ten thousand signatures calling for a referendum on women's voting rights. In 1915, she served as associate editor for the *Birmingham Magazine*, published by the Business Men's League.

According to Don Haarbauer in his 1973 doctoral dissertation "A Critical History of the Non-academic Theatre in Birmingham, Alabama," theater in Birmingham is unique in the South because the city was founded after the Civil War and therefore has few ties to the society of the "Old South." The city never had an aristocracy devoted to the arts. Instead, artistic interests were left to the middle class. Haarbauer noted that this allowed theater to thrive downtown for many years. It started to see its decline, however, with the rise of suburban multiplexes.

LYRIC THEATRE

Designed for Vaudeville

The Terminal Station was one of the grandest structures that ever existed in this city, yet it was demolished in 1969 despite public outcry. That will not happen to the Lyric, provided we can make the cause of saving the theatre a matter of civic conscience. Once again, we have something widely acknowledged as beautiful, valuable, historic and worth saving. Once again, we have two choices—tear it down or stake a different future on it.
—Glenny Brock, Lyric Theatre volunteer coordinator

When the Lyric opened in 1914, it was advanced not only in terms of its reinforced concrete construction and technology, but also in that it mixed two enterprises under one roof—a theater and commercial offices—which was a new concept at the time.

Real estate developer Louis V. Clark purchased three adjoining lots and hired the Hendon Hetrack Construction Company to construct a six-story office building and theater on the property. Clark partnered with Jake Wells, owner of a number of theaters in the South, including the Bijou Theatre one block west, to operate the theater.

Built for B.F. Keith's vaudeville circuit, the Lyric is one of the few theaters still existing that was specifically built to maximize the acoustics and close seating needed for vaudeville shows. Stars and acts such as Sophie Tucker, Will Rogers, the Keaton Family Acrobats (with Buster Keaton), Milton Berle, Fred Allen, Jack Benny, Belle Baker, the Marx Brothers, Marshall Montgomery, Mae West and Gus Edward's Kid Kabaret with George Jessel and Eddie Cantor appeared on stage.

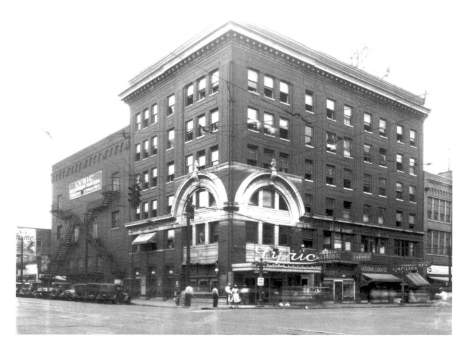

Lyric Theatre, 1930. *Birmingham, Alabama Public Library Archives.*

Starting with opening night, January 14, 1914 (when cartoonist Rube Goldberg shared a bill with four other comedians and musical acts), the Lyric was the only integrated theater in Birmingham. Although it had segregated entrances and seating, the Lyric was the only theater in the city where blacks and whites saw the same show at the same time at the same price.

By the time the Alabama Theatre opened in 1927, though, vaudeville was already on the decline, slowly being replaced by movies. By the late 1930s, the Lyric had become the dollar theater of its day, showing second runs of films that had made their local debuts at the Alabama or other nearby theaters with modern equipment and air conditioning.

The Lyric originally had 1,583 seats spread across the main floor, two steep balconies and two opera boxes. A center section at the front of the stage had a water tank underneath for aquatic shows. "We don't know for sure that any water shows actually took place there, but we know that the Lyric was capable of handling them, and that such shows were being done at the time," said Ward Haarbauer of the UAB drama department in 1978.

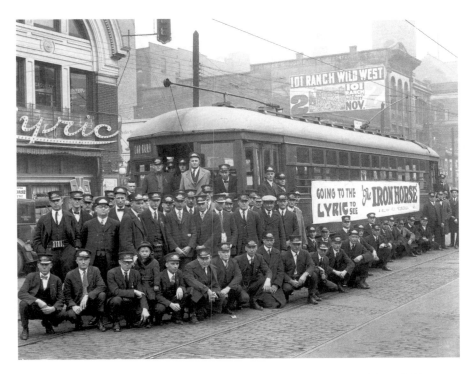

Streetcar in front of the Lyric Theatre, 1924. *Birmingham, Alabama Public Library Archives.*

There were twelve separate exits, fifty-five fly-lines and "the most complete light-dimming system in the South." The Lyric made an attempt at air conditioning by using two tons of ice under the stage, with fans blowing the cool air out over the audience.

A gold-leafed and painted asbestos curtain hung on the stage beneath a proscenium, which featured a large mural known as *The Allegory of the Muses* that was painted by local artist Harry Hawkins. The fire curtain actually had the word "ASBESTOS" printed in script across the center. It was the latest technology, and it was a badge of honor for the theater. Having it meant that any fire that broke out on stage would not spread to the audience.

Beneath the stage is a series of dressing rooms, each about eight feet square with sinks in the corners. It's the theater's acoustics, however, that really set the venue apart from modern facilities. Built for non-amplified voices and instruments, the balconies rise at a steep angle.

After a sudden closure in early 1915, the former vaudeville house reopened with a less prestigious "Three-a-Day" variety program. Soon after, even that

format was dropped, and the stage began hosting continuous-run programs with a house repertory company. All performances were guaranteed to be free of offensive words, expressions and situations.

The 1920s brought more competition for the Lyric to Birmingham. The Masonic Temple Theater was completed in 1922, and the Ritz and Empire Theaters opened in 1926. On Sunday evenings, the new Independent Presbyterian Church began using the theater.

The touring A.B. Marcus Revue brought a large cast and chorus line to the Lyric in 1926, and the theater hosted its own stock dramatic troupes in the off-season. Russell Filmore's Favorite Players, with Jerome Cowan, took to the stage with light comedy from 1927 to 1930.

With the Great Depression came more trouble for the Lyric. Jake Wells, his funds overextended, lost his chain of theaters and ultimately committed suicide. Ownership of the Lyric reverted to the mortgage company, which leased it to the Schubert organization. The Lyric continued to present vaudeville acts, but the Depression and competition from movies and radio led to its decline and closure in 1930 or 1931.

In 1932, brothers Ben and L.A. Stein of Jacksonville, Florida, reopened the Lyric as a movie theater, with a new Western Electric sound system. They scheduled four feature films each week, beginning with Will Rogers in *A Connecticut Yankee in King Arthur's Court* on April 25 of that year. Ben returned to Florida, while his brother remained in Birmingham as manager. According to the April 24, 1932 *Birmingham News*:

> *One of Birmingham's larger theaters, which has been closed more than a year, will resume its place in the amusement world Monday, when the Lyric reopens as a picture theater under the direction of Ben and L.A. Stein. The Messrs. Stein took a long time lease on the theater and have spent several thousand dollars installing Western Electric sound devices and refurbishing the house in every way.*

Later the same year, it was leased to the Paramount and the Wilby-Kincey circuit to operate it as a second-run theater, often showing movies that had their local premieres across the street at the Alabama.

Another major renovation in the early 1940s included new projection equipment. As the October 17, 1945 *Birmingham Post* noted, the Waters Theater Company bought the Lyric out of foreclosure for $400,000 and continued to lease it to Paramount as a second-run house:

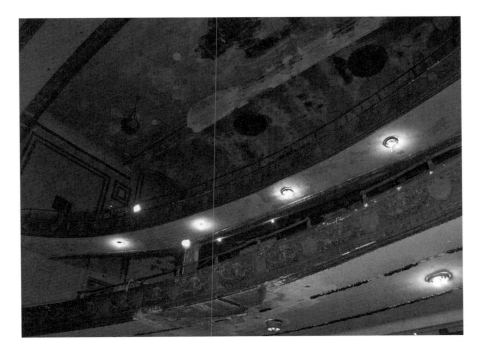

Lyric Theatre interior, 2011. *Photo by Kyle Crider.*

Several years back the Lyric was completely remodeled, from stem to stern, and it boasts the newest of equipment, both along production lines and in seating space and accoutrements. Today, it does a flourishing business, both for the reason that it shows only first run pictures from the Alabama—and because of its quiet comfort and modernistic atmosphere.

In 1954, the opera boxes were removed to accommodate a fifteen- by thirty-six-foot-wide screen for CinemaScope films. Live performances returned with a weekly "Saturday Night Jamboree," hosted by "Uncle Jim Atkins" and broadcast on WBRC-AM. Among the jamboree musicians were Gene Autry and Roy Rogers.

The theater closed its doors again in 1958; however, the adjoining office building remained open. In 1964, the Women's Committee of 100 investigated the cost of renovating the Lyric as a nonprofit civic hall. The project never materialized.

In the early 1970s, friends and old movie buffs Dee Sloan and Robert Whorton reopened the theater as the Grand Bijou Motion Picture Theater,

Above and opposite: Interior of the Lyric Theatre, 2011. *Photos by Kyle Crider.*

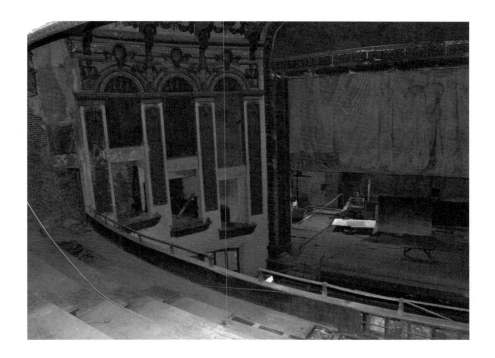

a revival house showing pre-1940s pictures. They refurbished the main floor with new lobby furnishings, including Victorian sofas and a Czechoslovakian chandelier. The enterprise lasted less than two years. The once-grand vaudeville showplace then fell to showing "adult movies," first as the Foxy and then as the Roxy.

Among the last showings was the 1972 pornographic film *Deep Throat*, after which, the story goes, the projectionist was arrested for violating Birmingham's blue laws. The seats were torn out in the 1970s and have never been replaced.

The theater had one more time in the spotlight in 1976's *Stay Hungry*, starring Jeff Bridges, Sally Field and Arnold Schwarzenegger in one of his first roles. The Lyric's twin fire escapes on Eighteenth Street North were populated by bodybuilders posing as contestants in a Mr. Universe competition during the final scene.

Emmett Weaver described the condition of the Lyric as it continued to fall into decline in a November 1979 edition of the *Birmingham Post-Herald*:

> *Now nearly a half century later, only a skeleton remains of the once-famous showplace at 1800 Third-av. N. Only the shadows, the peeling paint,*

creaking floor and the eerie sound of an occasional rat foraging for food, where once there was laughter and music.

Such was the bleak picture until last Friday, when a delegation of dedicated Birmingham theater-lovers, headed by Miss Rebecca Jennings, got together and decided to "light up" the old one-time vaudeville and movie house, if only for a short interval.

Friday they invited a subcommittee of four from the Birmingham Committee of 100 to come down to the theater and see for themselves the possibilities for "restoration."

At the same time that they were inspecting the theater's now dust-laden interior, they were treated to an actual performance on the Lyric's stage.

Yet again, the Lyric went without restoration. The theater's doors closed for good in the early 1980s. The Lyric Theatre and its adjoining six-story office building now belong to Birmingham Landmarks Inc., the nonprofit organization that owns and operates the Alabama Theatre. Recent estimates indicate it may take $15 million to $18 million to completely renovate the theater.

"Look past the peeling lead paint, broken railings, dilapidated seats, crumbling plaster and faded artwork at the once-revered downtown vaudeville house, and remnants of a glorious space begin to emerge," wrote Michael Huebner in a recent article in the *Birmingham News*.

A popular misconception that reopening the Lyric might hurt the Alabama is just one obstacle faced by those working to restore the theater. Actually, the opposite is true. The two theaters, designed for different types of events, will draw a variety of crowds to the downtown area, increasing potential audiences for both.

The Lyric is ideally suited for live performances, with a capacity for 1,200 and massive fly space that accommodates sets and backdrops. It also has dressing rooms with backstage access. The Alabama has 2,250 seats and was built for showing movies. It has limited fly space and virtually no wings. The Alabama has the Mighty Wurlitzer, with its multi-instrument sound system built into the walls; the Lyric has pin-drop acoustics.

Glenny Brock, who coordinates the Lyric's volunteers, describes the theater as uniquely Birmingham. On one particular Friday night, she said, a retirement party was held in the theater's lobby, while across the street at the Alabama a crowd gathered for the *Rocky Horror Picture Show*. A few doors down, a Magic City Classic party was underway at a nightclub. Each event was a magnet for a different demographic, she said, but the city's theater district is a melting pot, with the Lyric at its center.

THE FIREPROOF HOTEL THAT BURNED

Absolutely Fire-proof. Finest hotel building in the South. Elegant appointments and table service. Every room an outside room.
—F.W. Jewell & Co., Proprietors

This advertisement appeared in the *Evening News* on August 31, 1889. On July 21, 1894, that claim was proven false, however, when flames completely consumed the "absolutely fire-proof" Caldwell Hotel building in just three hours. The fire destroyed the Johnston-Hawkins building across the street as well.

The Caldwell, completed in 1889, was a six-story, one-hundred-room hotel located on the northeast corner of Twenty-second Street and First Avenue North in downtown Birmingham. The hotel's 165-foot height distinguished it as Alabama's second high-rise building (after the Moses Building, constructed in Montgomery in 1887). The fire caught first in its gilded dome and observation tower. A salon under the dome hosted frequent high-stakes poker games.

Smoking ruins soon replaced the largest and finest hotel in Alabama, said to be matched for elegance only by the Ponce de Leon Hotel in St. Augustine, Florida. No lives were lost in the blaze, which was controlled during the night. News of the discovery of the bust of Dr. H.M. Caldwell, owner and president of the Caldwell Hotel Company, spread nationally. The bust, still on its pedestal in a niche of the wall in the office, was caked with ashes and plaster but was not cracked by the fire. The bust showed the

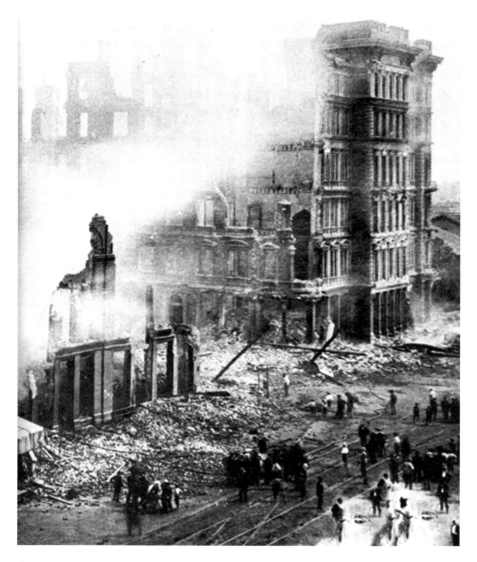

Caldwell Hotel after the July 21, 1894 fire.

features of Dr. Caldwell, looking on the ruins of the once splendid building. Still distinctly visible above the bust was the coat of arms of Alabama and the motto "Here We Rest."

The Caldwell's rotunda was described as magnificent, and its elaborate, two-storied dining room, which measured forty-eight by seventy feet, was

the scene of many festivities, including a luncheon for President Benjamin Harrison when he visited Birmingham in 1891.

Its parlors and ballrooms hosted the annual balls of the Fortnight, Monogram and Cosmos Clubs, as well as numerous other meetings and events. The hotel served as headquarters for the Alabama team for the first game between Alabama and the Agricultural and Mechanical College (Auburn University) in 1893 and played host for the proceedings of the 1894 Confederate Veterans Reunion, which drew more than ten thousand visitors to the city.

After the fire, there was nothing left except a few bare walls to remind Birmingham that its finest hotel was gone. The empty walls stood for several years until Goodall-Brown Dry Goods Company acquired the property in 1906. If nothing else, Birmingham did learn a lesson from the fire: adequate fire protection in the city was necessary if the city was to grow. It had been caught without the proper equipment and had to call for help from Montgomery and Meridian, Mississippi. Because of the Caldwell fire, the city council took the necessary steps to maintain a proper fire department with good equipment.

The Caldwell was incorporated, with $100,000 in capital, on February 3, 1886, by officers of the Elyton Land Company. They named it for their president, Henry Caldwell, who agreed to allow his own residence to be moved to Fourth Avenue North to make way for construction. Architect Edouard Sidel was commissioned to create the design and Henry M. Allen hired to oversee construction at a projected cost of $250,000. It occupied a 150-foot-square plot, with an open courtyard in the center giving light to each room.

Caldwell died in 1895, one year after the hotel named after him burned to the ground. He is buried at Oak Hill Cemetery. Caldwell Park and Caldwell Avenue still bear his name.

THE HEAVIEST CORNER ON EARTH

"The Heaviest Corner on Earth" isn't really the heaviest corner on earth of course. But it is a striking tribute to Birmingham's miraculous growth in the early 1900s and an important legacy from the city's formative years.
—Dilcy Windham Hilley, Greater Birmingham Convention and Visitors Bureau

I t's a bird! It's a plane! It's a…Human Fly?

On January 30, 1917, a crowd of thousands assembled in the streets to witness Harry "the Human Fly" Gardiner climbing the exterior of Birmingham's Empire Building. Gardiner was an American who became famous for climbing buildings after his first climb in 1905. He successfully climbed more than seven hundred buildings in Europe and North America, usually wearing ordinary street clothes and using no special equipment.

What was so special about the Empire Building? For one, it was (and still is) part of Birmingham known as the "Heaviest Corner on Earth"—a claim to fame that someone like Gardiner could hardly pass by.

At the turn of the twentieth century, Birmingham was a small town of two- and three-story buildings. During the industrial boom from 1902 to 1912, four large buildings were constructed at the intersection of the city's main streets. The buildings, which were four of the tallest in the South, appeared on the city skyline in such rapid succession that the corner they occupied became known as the heaviest in the South and, later, the heaviest on earth.

The Woodward Building, constructed in 1902 on the southwest corner of First Avenue North and Twentieth Street, was the city's first steel-frame

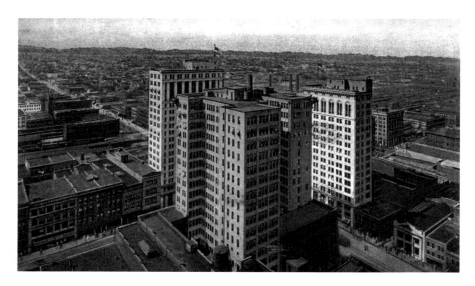

The "Heaviest Corner on Earth," 1918.

skyscraper. In 1906, the sixteen-story Brown Marx Building rose on the northeast corner; in 1908, an addition more than doubled its size. The Empire Building, constructed on the northwest corner in 1909, and the John A. Hand Building, built on the southeast corner in 1912, completed the so-called heaviest corner. Today, these buildings represent the most significant group of early skyscrapers in the city.

The Woodward Building is a ten-story, 132-foot-tall Chicago-style office building financed by William Woodward and was one of the earlier designs of architect William Weston, who collaborated with the Stone brothers of New Orleans. At the time of its construction, no building in Birmingham was close to its size. Doubts were raised about the ability of the local office market to absorb the added space. Nevertheless, the Woodward Building was fully leased at completion and was eagerly followed within a few years by several larger office towers, including the three others at the same intersection. In 1983, the Woodward Building was added to the National Register of Historic Places.

The Brown Marx Building is a 193,000-square-foot, sixteen-story, 210-foot-tall Chicago-style steel-frame office tower. From its completion in 1906 until it was eclipsed by the Empire Building three years later, it was the tallest structure in Birmingham. The building is located on the former site of Charles Linn's National Bank of Birmingham, also known as "Linn's

Folly." It was 1873, a time of national economic strife, and Linn, a major stakeholder in the city, persevered with his building plans despite warnings from his detractors. Upon its completion, Linn hosted Birmingham's first "Calico Ball" on New Year's Eve in the building.

The gala event of five hundred guests marked the culmination of a hard year in Birmingham's infancy and set an optimistic tone for the coming year, during which the fortunes of the city improved greatly. At Linn's urging, and in acknowledgement of the city's financial woes, many of the ladies and gentlemen in attendance had their ball gowns and evening suits fabricated from calico. Linn modeled a brown and tan dress suit with oversized buttons.

The ball has lived on in the city's historical lore. Having one's family name among the roster of attendees long signaled membership among the city's oldest and most loyal families. The gala is depicted on Eleanor Bridges's monumental *Cyclorama of Birmingham History*, which was designed for the lobby of the Brown-Marx Building, built on the original site of "Linn's Folly."

The Brown Marx Building was named for Otto Marx of Marx & Company and Eugene L. Brown of Brown Brothers, early tenants of the structure. (The alternate name, the Eugeneotto Building, was mercifully rejected early on.) It was built in two phases, beginning with a narrow sixteen-story tower on the corner, which was completed in 1906. The immediate success of that building encouraged the builder to more than double the overall size of the building over the next two years. In 1908, the footprint of the building was expanded, creating a U-shaped plan with an average of about twelve thousand square feet per floor and windows providing natural light to every office.

The Empire Building is a sixteen-story, 247-foot-tall Classical Revival–style skyscraper constructed on the former site of the Bank Saloon in 1909. When it was built, it was the tallest building in Alabama. Within four years, that honor was passed to the American Trust and Savings Bank Building on the opposite corner.

The Empire Building was developed by the Empire Improvement Company, which was headed by Robert Jemison. The construction was financed in part by a mortgage loan from the Metropolitan Life Insurance Company, the first such deal made by an insurer for development.

In 1965, the building was purchased and renovated for the newly formed City National Bank, which renamed it the City National Bank Building. In 1982, the Empire Building was added to the National Register of Historic Places.

The new owner of the iconic Empire Building, John Tampa, said that he plans to convert the downtown Birmingham landmark into "low-income

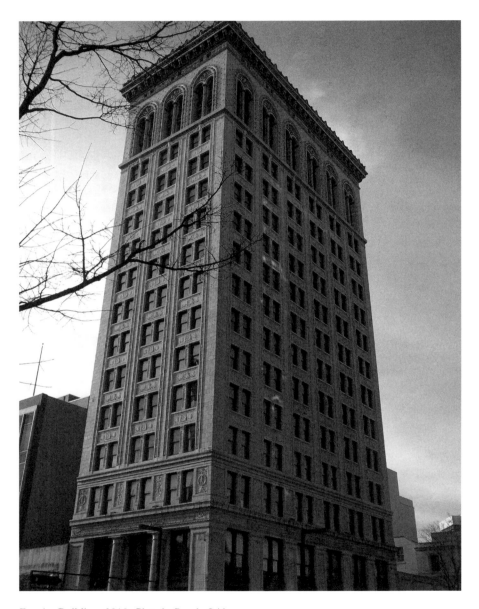

Empire Building, 2013. *Photo by Beverly Crider.*

apartments." Tampa said that financing was the deciding factor in his decision not to pursue his initial plans, which called for a boutique hotel in the sixteen-story building.

The John A. Hand Building (built as the American Trust and Savings Bank Building and then renamed the American-Traders National Bank Building, it was later called the First National Bank Building, before being renamed to honor John A. Hand, president of First National, in 1970) is a 284-foot-tall, twenty-one-story Classical Revival skyscraper constructed in 1912. It was the tallest building in Alabama for one year before being surpassed by the City Federal Building. The John A. Hand Building was added to the National Register of Historic Places in 1983.

The grouping of buildings on the "Heaviest Corner on Earth," while no longer the tallest, still provides an awe-inspiring view. The marker heralding the history of this site is located outside the Empire Building, yet it is overlooked by many. One afternoon visit found it being used as a trash can for discarded coffee cups. The numerous visitors and employees in buildings in downtown Birmingham pass by this corner on a daily basis without ever knowing the remarkable role it played in Birmingham's development as a great city of the South.

THOMAS JEFFERSON HOTEL AND THE WORLD OF ZEPPELINS

Southern charm and hospitality at its happy best, wonderful best. That's the pride of Birmingham—The Hotel Thomas Jefferson.
—*early newspaper advertisement*

Many visitors to Birmingham, and even longtime residents, probably look right past the old Thomas Jefferson Hotel, a mere shell of its former glory. If they notice it at all, they probably wonder about that broken mast atop the building, never dreaming that it once stood waiting to dock passenger zeppelins arriving to the Magic City.

Once touted as being "the pride of Birmingham," the Thomas Jefferson Hotel (renamed the Cabana and, later, Leer Tower) was completed in 1929 as a 350-room hotel. Finished during the Great Depression, it went bankrupt before it even opened.

The architect of the Thomas Jefferson Hotel was David O. Whilldin, a Philadelphia native who relocated to Birmingham because he wanted to work on "buildings that didn't just shoot way up in the air." He designed the $500,000 project in 1925.

For decades, the hotel struggled to keep up with the city's other hotels, watching as Birmingham grew to the north and east, leaving it alone except for a few restaurants and shops. It has remained vacant since 1983, when public health officials declared the building uninhabitable. In its day, however, its luxury status made the Thomas Jefferson a prime spot for celebrities visiting the city, including Presidents Herbert Hoover and Calvin

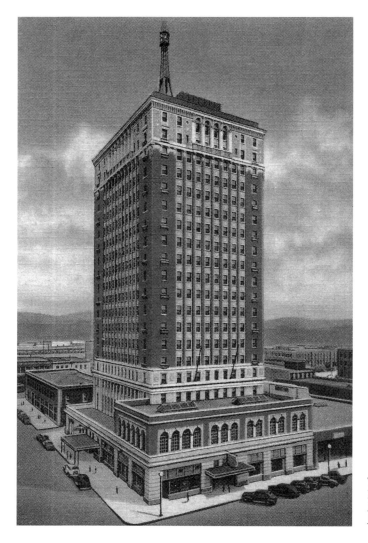

Thomas Jefferson Hotel. *Tichnor Bros. Inc., Boston, Massachusetts.*

Coolidge and entertainers George Burns, Jerry Lee Lewis, Mickey Rooney and Ethel Merman. A special suite was reserved for University of Alabama coach Bear Bryant during the school's games at Legion Field in the 1970s.

In a 1987 *Birmingham News* article, Sammy Ceravolo, a co-owner of the building when it was known as the Cabana and operator during the 1970s, said that he remembered the band Alabama spending time in the hotel before they were famous. "We threatened to kick them out. Our building was not wired for a lot of lights and when they played their music, they must

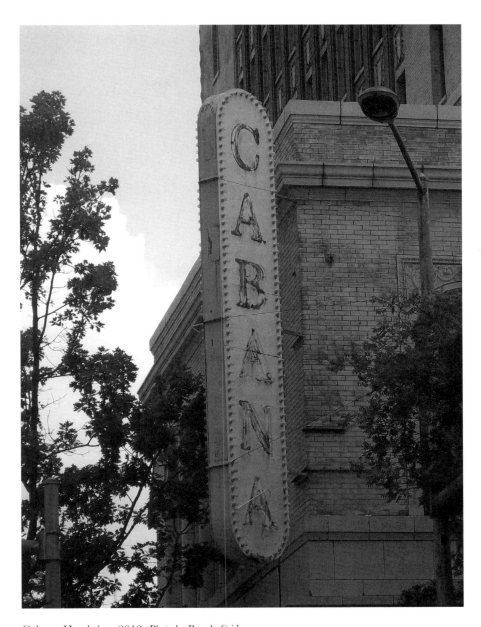

Cabana Hotel sign, 2012. *Photo by Beverly Crider.*

have blown out our fuses 10 times. We told them if they didn't quit, we could kick them out."

Perhaps the hotel's most unique feature, however, is the mooring mast atop the northeast corner that was designed to tie down hot-air balloons and zeppelins, thought to be the future in transportation.

A large vertically oriented painted sign for the Thomas Jefferson Hotel is still visible on the brick-clad west side of the tower. At one time, the letters were outlined with neon tubes, fabricated and installed by Dixie Neon.

The ground floor of the hotel originally had space for six shops, and the basement included a billiard room and barbershop. The ballroom and dining rooms on the second floor opened out onto roof terraces from which the main tower rose. In 1933, the hotel underwent an "improvement project," during which some of the retail spaces were absorbed by a larger hotel lobby with an electric fireplace. The dining room was expanded, and a banquet room was constructed over part of the roof terrace.

"The 1920s and 30s were the glory days of the downtown hotel," reported a 1981 *Birmingham News* article. "A person could walk a few blocks in the downtown Birmingham area and pass several high-class hotels with names like the Tutwiler, Redmont, Molton, and Jefferson. A man could come into town with just a suitcase, put down a few dollars, and have a classy place to eat, get a haircut, hear some music, meet some people, and live."

That era passed, yet the Thomas Jefferson struggled on. Its marquee was removed in 1951 by the order of Birmingham city commissioner Bull Connor, who cited an old ordinance against erecting posts on sidewalks. Unfortunately, the marquee was supported by such posts.

In 1966, the hotel underwent another major renovation, adding new carpeting, ice machines and automatic elevators in anticipation of new business from the recently announced Birmingham-Jefferson Civic Center. It turned out that the hotel was too far away from the BJCC to attract convention attendees, and the hotel's hopes for renewal were dashed yet again.

In 1972, the hotel's owner, the American National Insurance Company of Galveston, Texas, traded the building to Ernest Woods in exchange for three acres of land on Red Mountain. Woods sold the property to TraveLodge franchisees W.C. Maddox and Sam Raine. It was renamed the Cabana Hotel, and a new neon sign was erected on the rooftop. The aging hotel was well past its prime and continued to change owners. By 1981, it was functioning as a $200-per-month apartment building with fewer than one hundred residents, and it was forced into foreclosure by 1983.

"Back in 1980 when I moved to Birmingham, I was sent to a tax accountant in the Cabana Building," remembered John McDole, a Birmingham real estate broker. "I think the rooms on some floors were used as offices. I recall crossing the lobby with a sinking heart as I stepped over cracked marble floors in what was once a pretty grand lobby reduced to cracked plaster, faded and peeling paint."

During the last decade, downtown Birmingham has seen the conversion of many old department stores and warehouses into high-priced loft apartments. Just down the street from the old Jefferson Hotel sits the majestic renovated Alabama Theatre, which hosts performances and screenings of classic movies. Still, the Thomas Jefferson sits in decay, its doors boarded up for thirty years.

Preservationists hope that the rediscovery of the downtown by developers eventually will reach farther down the street to include a hotel long drenched in decay. The scene was much different in 1929, when Birmingham newspapers declared the two-hundred-room Thomas Jefferson Hotel as one of the finest in the country. Built to host huge gatherings, the $2.5 million facility was stocked with seven thousand pieces of silverware, five thousand glasses and four thousand sets of linen.

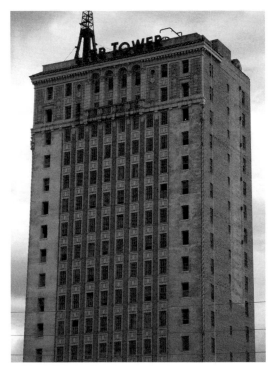

Bill Muellenbach was a twenty-three-year-old bellboy in 1936, when he said the hotel was tightly supervised by a "snobby" manager and his wife, according to a 2002 article in the *Birmingham Business Journal*. While management was not at the top of employee popularity lists, Muellenbach conceded that the hotel was a showplace with unparalleled amenities.

When the employees were not carrying luggage and serving guests, they operated

Leer Tower, 2012. *Photo by Beverly Crider.*

a popular side business at the hotel. In the age of prohibition, clever methods were used to meet the needs of thirsty guests. Muellenbach said that he would buy his "Pensacola rye" from the nearby police station to sell to hotel guests.

In 2005, the Leer Corporation of Modesto, California, announced a $20 million proposal to convert the building to upscale condominiums, to be known as the Leer Tower. That proposal fell through after disputes over ownership, and the property went into foreclosure in July 2008, but not before the Leer Tower sign was added to the building. The building, left gutted by Leer Tower Birmingham LLC and without utility services after the foreclosure, fell further into disrepair with the basement flooded and vagrants squatting in the upper floors.

Preservationists still hope for the restoration of a once-glamorous part of the Birmingham skyline. In July 2012, the nonprofit Thomas Jefferson Tower Inc. was organized to raise funds to purchase and renovate the building.

AVONDALE MILLS AND COMMUNITY

People sure can live with and around a lot of interesting things and places and know little or nothing about them. Like, for example, Avondale Park. We used to go out there on the streetcar when they had the old paper-eating Billy Goat, Miss Fancy the elephant, and a few other assorted and out-of-place animals.
—*Robert W. Kincey*, Birmingham News, *1960*

Avondale was a company town built around Avondale Mills east of Birmingham. Incorporated in 1889, the city was annexed into Birmingham in 1910 and is now divided into three separate neighborhoods: North Avondale, East Avondale and South Avondale. The town was named after the Cincinnati suburb of Avondale, which impressed the land company members who traveled there to seek backing for their development.

The first residents of the area gathered around "Big Spring" in the hills of Red Mountain, now the site of Avondale Park. The natural spring was already known to stagecoach travelers in the mid-nineteenth century and was said to have the sweetest waters in the region—far superior to well water available in the city. It was transported downtown and sold for twenty-five cents per barrel. Located near the junction of Georgia Road and Huntsville Road (present-day Fifth Avenue South and Forty-first Street), it was part of a large land grant given to two-time Jefferson County sheriff Abner Killough.

In Wilson's Raid of 1865, a brief skirmish erupted between Union soldiers watering their horses at the spring and some of the local guard. The only

injury was caused by a bullet that hit Mrs. Killough, who was sitting on her front porch knitting.

Killough sold the land around the spring to Peyton King, who built his home beside it. For a long time, the site was known as King Spring and was considered a popular place to picnic. The Avondale Land Company purchased the land from King, who specified that the forty acres surrounding the spring remain dedicated as a park. The company financed a mule-drawn streetcar line along First Avenue North to the proposed business district on Forty-first Street.

In 1872, the Alabama Great Southern Railway extended along the valley a few hundred yards north of the spring. Within a few years, the Great Southern had been joined by the Seaboard Air Line Railway and the Georgia Central Railway. Seaboard built a roundhouse and yards in Avondale.

The first school in Avondale was established privately before the 1880s, using a small two-room frame house in the "pine grove" near King Spring. The former school site was located on what is now the north side of Fifth Avenue South between Forty-third and Forty-fifth Street South.

AVONDALE MILLS

When the Trainer family decided to expand their Pennsylvania textile business south in the 1890s, they looked toward Birmingham because of its proximity to inexpensive cotton sources and labor. In exchange for stock in the company, Birmingham civic leaders agreed to invest $150,000 in private funding to build a mill.

The Trainers accepted the offer and sought an Alabamian to invest $10,000 in the project and assume presidency of the mill. They approached Braxton Bragg Comer, a successful cotton farmer and businessman who wanted to support an industry that would employ both women and men in Birmingham.

Comer agreed to take the position and, as president, became the driving force behind Avondale Mills in its early years, even buying and weighing cotton and selling the final product, typically dyed and undyed cloth and yarn, according to Lynn McWhorter of Auburn University's history department. McWhorter is working on his doctoral dissertation about the social history of millworkers in Avondale Mills. The Trainer family and other northern shareholders were bought out not long after Comer became president.

Avondale Cotton Mills on First Avenue and Thirty-ninth Street, 1908. *Birmingham, Alabama Public Library Archives.*

In 1897, Comer built the first mill in Avondale. By 1898, Avondale Mills was employing more than four hundred people as spinners, weavers and mechanics and generating $15,000 in profit. In 1906, Comer was elected governor of Alabama but remained president of the company. He did, however, turn over its management to his son James McDonald (Donald) Comer. The following year, Avondale Mills declared $55,000 in profit and produced almost 8 million yards of material.

Avondale drew large numbers of poor Alabamians, both black and white, who desperately needed work. A farm laborer who had been earning a potential $400 annually could work in a textile mill for a potential $700 annually. Comer's relationship to labor never progressed past his strong plantation paternalism, McWhorter wrote. "He controlled their working conditions at the mill, and by providing housing, recreation, and places of worship, he controlled some of their private lives."

One of Comer's first enterprises was to provide a place of rest and relaxation for his workers. He purchased land near Panama City, Florida, and created a beachfront park where members of the Comer family and

Avondale workers could swim, boat and fish. Later named Camp Helen, the park had a large central building and a number of scattered guest cottages. The mills closed at different times during the summer to allow employees to visit the camp. Black workers were allowed separate time to use the facilities. Comer also established a kindergarten at the Birmingham mill that was directed by his daughters, Mignon, Catherine and Eva.

Despite the amenities that B.B. Comer provided to his workforce, he and the company have been criticized for their extensive use of child labor in the mills and for opposing legislation to restrict such labor, according to McWhorter. Some families reluctantly allowed their children to work at the mill. Other families, who were accustomed to all members working on the farm, often welcomed the opportunity for their children to earn a paycheck. Comer claimed that families demanded their children have the opportunity to work; he simply responded to the will of his employees.

Labor reformers noted that there were important differences between farm work and factory work. On the farm, children worked hard but at their own pace, with no penalty for stopping. Mill work, however, endangered children because they often did not have the stamina or physical strength to work long hours. A misstep around a running machine was much more dangerous than getting tired in an open field.

When Donald Comer assumed management of Avondale Mills in 1907, he continued his father's business success. He expanded the company into Sylacauga beginning in 1913. These and other Avondale plants typically turned out rope, hosiery yarns, sheeting, indigo denims and heavy twills.

Comer began to take more interest in the well-being of his employees. He established night schools for adults in Avondale Mills, known as Opportunity Schools, in cooperation with the Alabama Department of Education. He also supported children of Avondale employees through no-interest loans for college education that he usually forgave if the student graduated.

Mill owners typically provided housing for workers and little else. Outhouses were often located between or behind the houses. Comer, however, located sanitation facilities inside, according to McWhorter, and the company charged only seventy-five cents per week for housing out of a salary of twelve to twenty dollars per week. The company built schools, which sometimes also welcomed children from the community, as well as churches.

Mill employees could live in the mill village, which had a dairy, a poultry farm and other amenities. Bragg Comer, another of B.B. Comer's sons, supervised the construction of Drummond Fraser Hospital, a thirty-five-

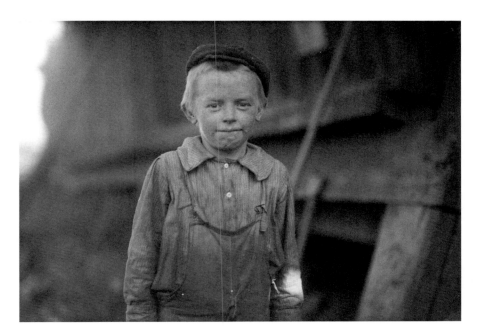

"Our Baby Doffer," Donnie Cole, Avondale Mills, 1910. *Library of Congress, Prints and Photographs Division.*

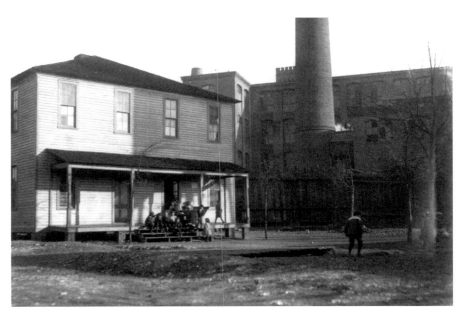

The "Mill School" at Avondale, 1910. *Photo by Lewis Wickes Hine. Library of Congress, Prints and Photographs Division.*

bed hospital for Avondale workers. At one point, Avondale even provided a canning plant, although employees had to pay for the cans. Avondale Mills also owned Camp Brownie on the Coosa River, which offered boating opportunities for employees and their families.

During the Great Depression, Alabama's millworkers saw production cuts, plant closings, pay shortages and shorter workdays. In 1933, when labor organizers started local unions in Birmingham, Comer reminded his employees of the many benefits they received and told them that unions were not necessary. Foremen took their cue from Comer and began letting union workers go. Meanwhile, textile workers in Alabama began walking out of mills in 1934 as part of a larger effort to protest declining wages. In July 1934, the evening shift in Avondale's Birmingham plant walked off the job—the only Avondale plant to join the movement. Comer closed the plant and did not reopen it until President Franklin D. Roosevelt called on all employees to return to work.

Comer's views on child labor gradually evolved during the 1920s from being initially opposed to regulating hours for women and children to supporting an effort to end night work by children and women in the cotton mills in the early 1930s. By 1934, he had come to support a national movement to end child labor.

During World War II, Comer was appointed to the War Labor Board to help curb work stoppages. Labor was demanding higher pay as company profits skyrocketed during the war effort. Also during this time, he created a profit-sharing plan for employees of Avondale Mills. Between 1948 and 1950, Avondale Mills shared more than $12 million in profits with its seven thousand millworkers.

Patricia Cloud "Cush" McCullough, a child of the mill, related the following:

My mother went to work in the mill at 12-years-old to help her mother raise her three younger sisters. My grandparents started in the early 1900s. Many, many people passed the mill going to work downtown every day, yet never knew of its existence. To start with, the mill itself was sandwiched right smack in the "middle," with town to its right and the city to its left. Thousands passed the large factory going to work and probably never looked to their right.

On the corner of 1st Ave and 39th St. N. not only did the people who hurriedly rushed to work each morning not know of its existence, but the "village people" knew little of their existence either. For their lives totally centered around the village—their own little town within a town. They

didn't have cars. Everything they needed for their families was provided by the Comers. There was a doctor who delivered all the babies at home. They all called him old "Doc Comer" (no relationship to the mill owners). I was the baby [of the family], *but the first to be born in a hospital...in 1949.*

The mill was one big family, with children playing at homes throughout the village, Cush said. Everyone knew whose kids belonged to whom. If one got in trouble, his parents already knew it by the time he got home. Their bond was strong, and they stuck together like glue, through births, deaths, marriages, depression, war and illness—as if they were kin, she said.

My paternal grandparents were George Thomas Cloud & Annie McNatt Cloud. He was a foreman in the mill and Grandmother was a weaver. Grandmother hosted most all the parties in her home and there were many! They lived in one of the larger houses like the bosses.

My maternal grandmother was Minnie Gillian Robinson. She was a spinner. Later, she opened her house for men to have room and board. She had three boarders. They got three square meals a day and shelter. Her first husband died when Mother was only six-years-old and she turned around and married his drunken good-for-nothing brother. That's why mother had to leave school and go to work in the mill. He would meet her on the corner after she got her pay and take her hard-earned money from her and go buy liquor. After work, Mother then had to take care of her three younger sisters (baths, school work, bedtime, wash, clean, etc.), while Granny Robinson worked the night shift.

Each house was numbered 1 through 129, according to Cush. The only house she remembers was at 118 Thirty-ninth Street. Her family moved from the village to East Lake in 1951, when Cush was three. She returned to the village regularly, however, to stay with her Granny Robinson until she started school. All of the houses had large backyards for a hen house and garden, she remembered.

Children were desirable workers at the mill because their small hands could get in between the machines, Cush added. Most of the mothers and fathers also allowed it because they desperately needed the extra money. When the inspectors would visit, the millworkers would hide Cush's mother where she wouldn't be seen.

My mother loved it from day one. She learned quickly and had the perfect skills to be a good little spinner...and she was the best. Instead of being

Naomi Robinson Cloud, spinner at Avondale Mills. *Patricia Cloud "Cush" McCullough.*

bitter, she took great pride at excelling in her job. My mother's personality was such that she was an obedient and mature child of 12. She not only never regretted working there so young, but missed it terribly when it closed. Many a girl or woman didn't last one day. Either they hated the constant noise of the machines, which gave everybody horrible headaches, or they didn't have the right skills to perform the job. Many lost hands, and other limbs, and died at the hands of these beastly machines. Mother just never let that enter her mind.

Also, there was NO TALKING! One couldn't take the chance of losing their concentration or they could be badly hurt. The windows were also closed up which made it dark in case one might get the bright idea to look out.

The only town or city they knew was theirs. Everything was provided within the village by the owners so the kids would be happy. Happy kids… Happy parents. The kids say they were the most blessed kids in the world for having so much. From interviewing hundreds, not a one says they missed out on anything. This is the only life they knew and they loved it. Can you imagine having 129 houses in the village and at least 4 or 5 children

living in each house? That's a lotta kids. They all felt related to one another because of the closeness. Just like family…and they were, really.

AVONDALE PARK

In 1885, a mule-powered streetcar began bringing visitors to the springs in the expansive forty-acre Avondale Park to bathe and picnic. The streetcar line was eventually upgraded to electrical power, and the resort became among the most popular day-trip destinations in the region. Upon Avondale's annexation into Birmingham in 1910, it became the city's largest park.

The original park had rock retaining walls to enclose wading pools fed by the springs, which were encircled by an iron fence and covered by a wooden shelter. Paved walks wound between the pools and benches and the picnic tables. Later, a covered gazebo was built. Avondale Cave, accessed from above the spring, attracted the adventurous. Quarrymen also searched the caves for slabs of marble to be processed at the nearby Avondale Marble Factory. The spring outlet and cave entrances were sealed off in the 1930s.

Avondale Park was described in the 1920 publication *Birmingham and its Environs* as one of the most beautiful parks in the city. "What may be called the background of Avondale Park over which are scattered the various enclosures of the zoo, is extremely picturesque and, in places, really grand. At one place from the base of a rocky clift [*sic*], a beautiful spring comes bubbling and dashing down into the grounds, feeding a considerable stream and several ponds. On rising ground, in the southern borders of the park, is located the attractive little public library, of which the Avondale people are so justly proud."

An amphitheater was constructed for the celebration of Birmingham's fiftieth anniversary in 1921. That same year, the Birmingham City Commission sponsored the construction and operation of a Model Poultry Farm, with room for 350 birds. In 1931, a secluded pavilion called "The Villa" was constructed on the hill at the rear of the park, and in 1936, the Birmingham Civic Symphonic Orchestra began playing free Sunday afternoon concerts at the park.

Birmingham mayor George Ward implemented many landscape improvements, including a nationally renowned rose garden. Over time, athletic fields and gravel walkways were added. In 1911, cages were erected

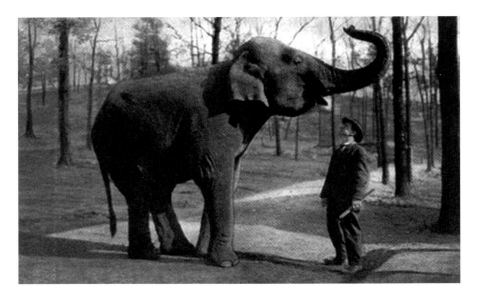

Miss Fancy, circa 1914.

in the southeast corner of the park for a small menagerie of animals that would later become the Birmingham Zoo. The star of the animal park arrived in 1913 in an unexpected turn of events. The January 27, 1929 edition of the *Birmingham News-Age Herald* described it this way:

> *The owner of a stranded circus had to part with some or all of his collection of wild animals. He had managed to reach Birmingham and put on several performances just off First Avenue, North, in the vicinity of 22nd Street.*
>
> *The Birmingham Advertising Club was putting on an industrial exposition, the first attempted here. The promoters felt the need of something more than mill, factory, furnace and mine products to draw people to their show. News of the stranded circus reached them, and of "Miss Fancy," the big elephant which had paraded the streets of Birmingham just a day or two before to the delight of the thousands of children and grown-ups, too. Someone conceived the happy idea of buying or hiring Miss Fancy for the industrial show. Her owner received the proposition with an open mind and eventually a trade was made in which the ownership of Miss Fancy passed to the Advertising Club.*
>
> *When the show was over the question of Miss Fancy's disposition arose. The Advertising Club realized it had an elephant, if not a "white elephant," on its hands and that she had an appetite in proportion to her size. A place in*

Avondale Park was fitted up for her and the quest for other animals to keep her company started. In the 16 years since that event Birmingham has made a fairly creditable start towards the building of a zoo.

Miss Fancy was reported to have eaten 150 pounds of hay and 3 gallons of grain per day. She consumed 60 to 115 gallons of fresh water daily and nibbled on popcorn, peanuts, apples and watermelons brought to her by visitors. Miss Fancy managed to grow from 4,800 to more than 8,500 pounds during her years in Birmingham. She was also said to be a drinker, consuming quarts of confiscated whisky provided by city officials during prohibition. The liquor was mixed with the elephant's feed as a treatment for constipation or chills. Apparently, her longtime caretaker, John Todd, had similar ailments that placed him in need of this same remedy, as he often appeared drunk in public.

Miss Fancy often escaped from her enclosure and was seen wandering the streets of Avondale, Woodlawn and Forest Park, enjoying samples from gardens and looking into windows. Once, in 1925, she knocked over the park's cookhouse and kicked over a few fire hydrants.

Donna Farmer, president of the Birmingham Boston Terrier Rescue, remembered hearing her grandfather, Willard T. Farmer, speak of Miss Fancy:

Pos loved telling of a time Miss Fancy got loose and sat on a car in the parking lot. While crumply, it was still drivable. [The car's owner] drove it home but was pulled over in such a wreck, they were concerned. The poor lady tried to tell the officer what happened but couldn't stop laughing for the absurdity of it. They assumed she was sauced and had been in a hit and run, so they took her in. Similarly, Pos got just as tickled telling the story and would dissolve into fits of giggles retelling it. I don't know how much embellishment might be in the tale, but I love the story and assume it true!

The $4,600 annual expense of keeping the animals led the park board to suggest closing the zoo as early as 1932. Former mayor George Ward, owner of the Roman-styled Vestavia estate on Shades Mountain, declined to take over Miss Fancy's care. He told the board, "Lions, tigers and elephants contributed to the downfall of the Roman Empire. No elephant will have the opportunity to bring about the disintegration of my Roman empire."

By 1925, in addition to Miss Fancy, the zoo featured an eight-foot diamondback rattlesnake, five alligators, two black bears, a zebu (called a

Avondale Park, 2013. *Photo by Beverly Crider.*

"Sacred Cow"), a buffalo, several peacocks, coyotes, hawks, owls, goats and monkeys. In 1934, the zoo—which had added a llama, a lynx, a wolf, a raccoon, a pheasant, three goats, five more alligators, an eagle, three rabbits and a gopher—was putting a strain on city budgets. The Birmingham Parks and Recreation Board suggested that the zoo could be updated with the proceeds of a $1 million property tax, as had been done in Memphis, but the proposal was ignored.

The city commission voted to close the zoo and sell the collection. Many of the animals were sold to zoos in Augusta, Atlanta, Washington and Attalla. The Cole Brothers–Clyde Beatty Circus purchased Miss Fancy, along with the zebu, llama and nine monkeys, for a total of $710. She toured with the circus as "Bama" in 1935 and 1937. In April 1939, the circus sold her to the Buffalo, New York zoo, which had been newly expanded with help from the Works Progress Administration (WPA). She remained there until her death in 1954.

During the 1940s, the closest thing Birmingham residents had to a zoo was another small collection of native species exhibited by the Birmingham

chapter of the Izaac Walton League (one of the nation's oldest conservation organizations) at Lane Park.

Renovations to the park began on February 28, 2011, with KPS Group as the project's architect and Stone Building Company as the contractor. The park officially reopened on November 19, 2011. The $2.88 million plan, funded by City of Birmingham bond money, included three new baseball fields; renovations to the amphitheater and its dressing room, the existing picnic pavilion and the existing pond; the creation of a spring-fed grotto and creek using an existing spring; a new concession and restroom building; new playgrounds; upgrading for all walkways to ADA standards; a new entryway at Forty-first Street; an expansion of the parking area; and an additional picnic pavilion. The park welcomes visitors with a new bronze statue of Miss Fancy, which was added as a centerpiece of the plaza.

BANGOR CAVE

Underground Nightclub and Speakeasy

Blount Springs had many attractive features, but none surpassed the mineral waters. The most popular among these was the "Red Sulphur," which was bottled in blue glass because, it was thought, glass of that color preserved the strength of the water.
–*James F. Sulzby Jr.,* Historic Alabama Hotels and Resorts *(1960)*

In Alabama, the big news of 1937 was the opening of what was touted as the "only underground nightclub in America," the Bangor Café Club. In its short year and a half of operation, it proved to be one of the most glamorous and controversial places in the South.

The nearby area of Blount Springs, the "Saratoga of the South," was making news long before that, though. In what might have been the first specific historical reference to Blount Springs, Davy Crockett was said to have spent time recuperating from a fever by a set of sulfur springs some miles north of Jones Valley, Alabama, in about 1815.

In 1828, J.H. Harris and J. Perrine purchased the property with plans to make it a renowned watering place for the "Western Country." Six years later, the resort was listed in the *Accompaniment to Mitchell's Reference and Distance Map of the United States.*

Colonel J.F.B. Jackson, a construction engineer for the South and North Alabama Railroad, realized the potential of the springs during the completion of a sixty-six-mile stretch of railroad between Birmingham and a point south of Decatur. He purchased several thousand acres of land in

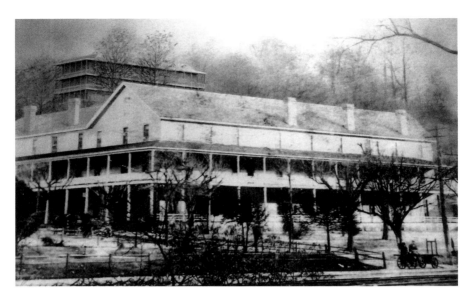

Jackson House Hotel, destroyed by fire in 1915. *Blount County Memorial Museum.*

the area, including Blount Springs, in 1871. On September 29, 1872, the last spike was driven to complete the line from Decatur to Montgomery, and soon after, Jackson built a small hotel, naming it after himself. Barely one thousand feet from the depot, the hotel served as a stopover for passengers and a "home away from home" for vacationers.

On July 12, 1878, Blount Springs' new Jackson House was opened to the public, replacing the temporary hotel that had been constructed six years earlier. In 1879, the Blount Springs Natural Sulphur Water Bottling Company began advertising medicinal benefits of the sulfur water, including treatment for skin diseases, sore eyes, gout, pimples, blotches, ulcers and even paralysis.

As the bustling community continued to grow, a new two-story hotel, the Mountain House, was completed in 1883 on an elevated site behind the Jackson House. The town of Blount Springs was officially incorporated in 1885.

In 1887, Jackson sold his holdings to J.W. and Mack Sloss, brothers who operated the Sloss Furnaces in Birmingham. They planned to make Blount Springs an even more popular resort for weary businessmen, with a sanitarium for invalids and a playground for children, while at the same time increasing its reputation as the rendezvous of southern society. A new bathhouse, with water connections from the sulfur springs, was built, and modernized plumbing was installed throughout the hotel.

Dignitaries, socialites and celebrities, such as Lillian Russell and Diamond Jim Brady, visited the resort. Plays, vaudeville performances, concerts, balls and galas were all a part of life at the vacation spot. After the turn of the twentieth century, however, the glamorous days of Blount Springs began to wind down.

The Sloss brothers sold their holdings to Mel Drennen of Birmingham in 1903. In 1914, the Louisville & Nashville Railroad, which operated the South and North as a section for many years, assumed complete ownership of the line. In November of that year, a new route was built, eliminating the tracks through Blount Springs.

On June 3, 1915, a fire started in the kitchen of the Main Hotel and spread to adjoining buildings, bringing a virtual end to the resort.

With the resort gone, the nearby Bangor Cave, just four miles northeast, was practically abandoned. The cave had been well known since the late nineteenth century. A small entrance was located on the side of the hill and was only about 3 feet high by 6 feet wide. Guarded by a rough gate and padlocked, the entrance sloped about 6 feet down until it reached the floor of the first chamber. Tours were conducted through the cave by candle and pitch-pine torch light. Band concerts were even held in the main chamber, which measures about 350 feet long by 57 feet wide and is about 20 feet high. A souvenir token was presented to all those brave enough to hazard the trip.

A 1935 edition of the *Avondale Sun* describes an afternoon outing by one group of adventurous souls from Avondale Mills:

> In the back of our camp house the woods and hills had intrigued us from the first, so we started out exploring them. Knowing that woods aren't so safe and hills hard to climb, we tried teamwork in our exploration. It seems as though some of my friends dug their toes into the mud and stretched their bodies to explore Bangor Cave, but only six had nerve enough to venture into the depths of the cave. Mr. and Mrs. Mangum came up during the afternoon and Mr. Mangum fearing he'd be a second Floyd Collins, turned back when he had gone as far as the foot log across the chasm. The journey through the cave by six noble ladies, Evelyn Neal, Flossie Preston, Novis Chandler, Mrs. Knight, Johnston and Busler was a drastic experience, and if you must know about the cave, they say, see for yourself, for we see everything, hear everything, but say nothing.

With the resort no longer providing visitors to the cave, it was almost forgotten. In the mid-1930s, property owner J. Breck Musgrove persuaded a group of investors to fund the construction of a nightclub—or, in prohibition

Bangor Cave bar, 1930s. *Blount County Memorial Museum.*

parlance, a speakeasy—in the cave. A new entrance was blasted open using dynamite, and a bandstand and bar were carved from the stone. The floor of the first chamber was leveled with the addition of concrete and covered with linoleum, and the second chamber was later turned into a lounge for female patrons. A locked and heavily guarded room housed slot machines, craps tables, roulette wheels and card tables.

One unique difficulty in preparing the speakeasy was the lighting. According to a Birmingham newspaper of the day, "electrical engineers studied the lighting possibilities for weeks, seeking to obtain proper effects. The results are that Bangor Cave, in the fastness of Blount County hills, will sparkle with lights like Broadway. The conduits are underground so as not to disturb the overhead stalactite formations."

After several delays, the Bangor Café Club finally opened on Saturday, June 5, 1937. Guests from Birmingham, Decatur, Cullman, Tuscaloosa and Montgomery arrived at the club by train on a spur line that emptied within a few feet of the newly created entrance, and motorcars arrived over a gravel-covered U.S. Highway 31.

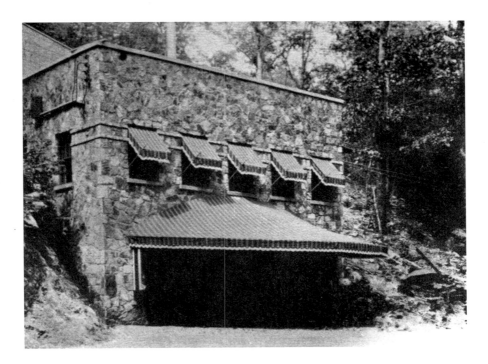

Entrance to Bangor Cave before the fire. *Blount County Memorial Museum.*

Raids and legal proceedings over the cave's operation began almost as soon as the nightclub opened, with Governor Bibb Graves ordering the local sheriff to shut down the club. After this first closing, a grand reopening was announced for a July Friday night, allegedly without liquor or gambling. On July 31, just after midnight, the newly appointed sheriff, Ed Miller, and eight Alabama state troopers headed to the club. An estimated crowd of two thousand was enjoying roulette wheels, slot machines and liquor.

"Hitting with a bang that reverberated over the entire state, our new sheriff, Ed Miller, raided Bangor Cave on Saturday night just after the clock had passed the midnight hour and made a haul not only in gaming tables, but in arrests and drinks that make wild men wilder," reported a Blount County newspaper that week.

The battle continued among the state, the county and the owners until January 1939, when the nightclub shut its doors for good. Early on the morning of May 8, 1939, neighbors noticed thick black smoke coming from the cave. Several raced to the site to find it engulfed in flames. Some thought that it was the retribution of a group of petty thieves who didn't find

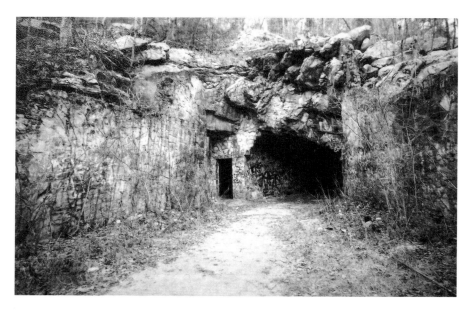

Bangor Cave entrance as it is today. *Blount County Memorial Museum.*

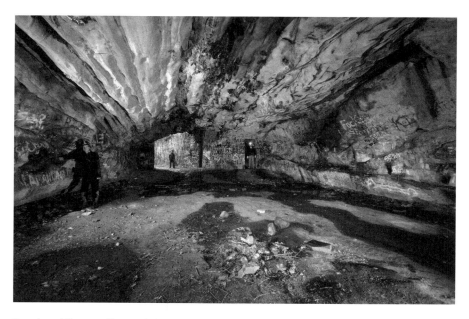

Interior of Bangor Cave as it is today. *Photo by Alan Cressler.*

anything to steal. Others thought that it was the work of lawmen trying to ensure that the club never opened again.

Visitors have continued to venture to the cave over the years, but it has become the target of vandals, with the walls becoming covered in graffiti and the initial chambers littered with trash. The bar and bandstand areas are still evident, but most other signs of the once-thriving nightclub have disappeared. At present, the cave is held privately and is not open to the public. No development is planned.

LANE PARK

What Lies Beneath?

As a beautiful breathing spot, its possibilities are even manifest to the ghosts of the
pauper dead who now look out on mansions of the millionaire and mayhap grin
to think that all things come to those who wait and that the whirligig of time has
transmuted their lowly beds into nooks of safety and beauty.
 —former Birmingham mayor George B. Ward

Visitors to the Birmingham Zoo and Botanical Gardens may be surprised
to learn that the park housing such beauty was constructed on burial
sites associated with "pest houses" in the area that dated to 1888.

Lane Park, originally called Red Mountain Park, is a large area on the
southern slope of Red Mountain near the western terminus of Highway
280. The two-hundred-acre site was purchased by the City of Birmingham
in a series of transactions dating from 1889 to 1902. The first purchase was
made under Mayor A.O. Lane.

In 1920, when the park was still known by its original name, George
Cruikshank described it in his book *Birmingham and Its Environs*:

> *Red Mountain Park contains 200 acres recently bought by the city for*
> *park purposes outside the corporate limits, about five miles from the heart*
> *of Birmingham. This land is undeveloped, but is well located for park*
> *purposes. It is a section of deep and rocky ravines, with wooded heights,*
> *and Birmingham's environs contain no more picturesque tract than what*
> *is known as Red Mountain Park. In this park is a magnificent spring of*

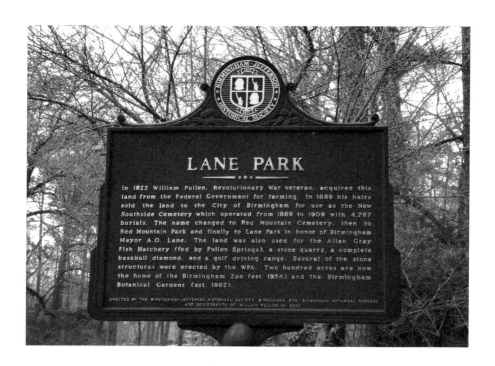

limestone water that is constant and abundant and supplies a beautiful stream that runs through the park and across the macadamized highway to the city reservoir.

Mayor Lane had a section of the site on the west side of Cahaba Road dedicated in February 1893 as a "potter's field," or pauper's cemetery. Since only Cahaba Road existed at that time, the records suggest that only the area within the current Birmingham Zoo was included. However, workmen removing dirt from a spot near the new rose garden of the Botanical Gardens in 1964 uncovered at least three graves, facing east. They also discovered the bones of one skeleton that was fairly well preserved. Other items retrieved were flint chips, a few copper items similar to shoelace tips, a small fastener like those used on ladies' apparel and a broken bottle with raised letters spelling "Birmingham." Signs of a wooden casket were plainly visible.

Known as Red Mountain Cemetery or "South-Side Cemetery," it was used for Jefferson County until shortly after the turn of the twentieth century. The cemetery was abandoned in 1909 when the Ketona Potter's Field was opened, and some 4,767 graves were left in place. There has been local speculation that some of the graves were moved to the Union Cemetery on Hollywood Boulevard, but no records support that. A smallpox hospital also was built on the park property, just south of a quarry where curbstones for First Avenue North were being mined.

In 1910, a tent city was erected in the area of the property near today's English Village, to be used in the treatment of tuberculosis patients, the first such establishment in north Alabama.

In 1934, the entire two-hundred-acre parcel was dedicated by the city council as a public park, named Lane Park in honor of Mayor Lane. In 1935, Thomas Brooks, landscape designer for the WPA, worked with the newly formed Birmingham Federation of Garden Clubs to sponsor the planting of more than five thousand trees and shrubs to form Lane Park Arboretum, which covered a portion of the current zoo.

Opposite, top: Historical marker for Lane Park, 2012. *Photo by Beverly Crider.*

Opposite, bottom: Historical marker for the first tuberculosis sanitarium, 2012. *Photo by Beverly Crider.*

B-23—Monkey Island, Birmingham Zoo, Birmingham, Alabama

"Monkey Island," first exhibit area at the Birmingham Zoo.

The park site was expanded in anticipation of the creation of the Birmingham Zoo, which took up fifty acres of the enlarged park. The zoo's first exhibit, "Monkey Island," was opened to the public on April 2, 1955. Another sixty-seven and a half acres were enclosed in 1962 when the Birmingham Botanical Gardens first opened.

The more than seventy spider monkeys that once called "Monkey Island" home were moved to the zoo's existing primate building in 1999. After the monkeys moved, alligators lived on the island until 2002, when they were moved and the zoo's duck exhibit settled on the island. Destruction of the island began on September 23, 2009, to make way for the new Africa exhibit.

BIRMINGHAM'S FIRST HOSPITAL

Despite repeated attempts to demolish it, the century-old hospital remains. It now stands as a historic landmark in the heart of UAB's twenty-first century hospital.
 —Tim L. Pennycuff, UAB archivist

Hillman Hospital has been a fixture in Birmingham's Southside since it first opened in 1887. Today, however, many people pass the old building without giving it a second glance. As the University of Alabama at Birmingham (UAB) Medical Center grew around it, Hillman blended into the landscape.

In 1884, the wives of a number of Birmingham business leaders formed the Daughters of United Charity with the purpose of organizing a hospital in the new city of Birmingham. They raised funds from public and private sources, and within three years, on March 9, 1887, the Hospital of United Charity was formally incorporated. Birmingham's first charity hospital opened on October 23, 1888, in space rented in an existing building on Twentieth Street, with twenty-eight patient beds in wards divided by gender and race.

For the next decade, the hospital was housed in locations around the city. A one-hundred-bed facility built specifically for the hospital burned to the ground in 1894. In March 1896, the hospital was renamed Hillman Hospital in honor of local benefactor Thomas Hillman, president of the Tennessee Coal, Iron and Railroad Company. His donation of stock and funds, amounting to about $20,000, kept the hospital open during the early

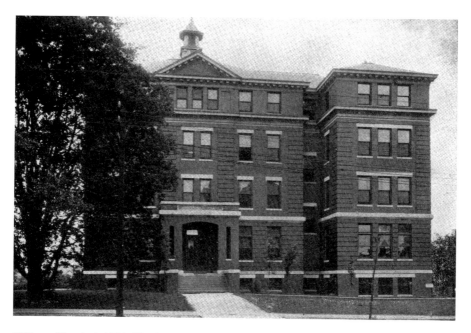

Hillman Hospital, 1908. *Birmingham, Alabama Public Library Archives.*

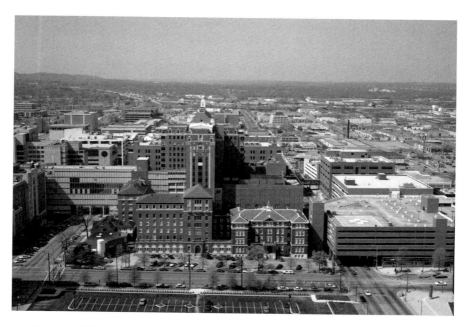

Aerial view of Hillman Hospital, surrounded by UAB Medical Center. *Library of Congress, Prints and Photographs Division.*

years. Hillman stipulated that the funds be shared equally among white and black patient wards. The following year, the Alabama legislature granted a charter to Hillman Hospital, and its management was given to the board of lady managers.

In 1901, the board acquired land on Twentieth Street South for the construction of a modern hospital. A groundbreaking ceremony was held on May 2, 1902. Designed by the firm of Charles and H.B. Wheelock, the four-story brick and stone building was formally dedicated on July 15, 1903.

In 1913, an annex was constructed to relieve overcrowded conditions, but this addition was far from sufficient for the city's ever-growing population. Another addition, the New Hillman Building, was constructed adjacent to the original facility and opened in January 1928. This expansion again proved to be insufficient for the number of patients seeking treatment, and a five-story building housing the hospital's outpatient clinics was completed and dedicated on November 19, 1939.

In addition to being Birmingham's first charity hospital, Hillman Hospital was also the site of many groundbreaking medical procedures. Birmingham physician Thomas Boulware introduced many of Alabama's obstetric firsts at Hillman: first pregnancy test administered (1929), first "bikini" Caesarean section (1932) and first OB/GYN residency approved in the state (1934). Boulware was particularly interested in indigent care—especially the area of black expectant mothers and their newborns. Boulware crossed racial barriers, for a time being one of only a few white doctors to deliver babies in black homes or perform life-saving Caesarean sections on black mothers in emergency labors.

In 1940, the 575-bed Jefferson Hospital opened, and in 1944, the Jefferson and Hillman hospital buildings were deeded to the University of Alabama and merged to form the Jefferson-Hillman Hospital, a component of the newly established Birmingham Medical Center. On May 28, 1955, the Jefferson-Hillman Hospital was renamed, and although it has undergone several slight changes to its name, since that time it has been known as University Hospital. Today, University Hospital is a major patient-care and research facility of the UAB Health System.

ST. NICHOLAS RUSSIAN ORTHODOX CHURCH

First South of the Mason-Dixon

A quiet farming village until the opening of its mines in 1886, Brookside emerged as a key player in the Sloss Company's mining empire in the late 19th Century. The mines attracted new settlers, some more desirable than others, and by 1900 Brookside had earned a well-deserved reputation as a lawless town. But the real spirit of Brookside was defined by its miners—hard-working Slovak immigrants whose influence on the small Alabama town can be seen to this day.
—Alabama Heritage *(Summer 2007)*

The town of Brookside, Alabama, was established on December 13, 1819, sixty-seven years before the first mine opened in 1886. It is thought to be among the first communities in the South settled by eastern European immigrants. These settlers established the first Russian Orthodox church south of the Mason-Dixon line more than one hundred years ago. Over the course of ten years, the Orthodox in Brookside built three temples. A tornado destroyed the first, which was dedicated to St. George. The tornado's winds were so devastating that townspeople said that hymnals hung from nearby trees.

The second temple, dedicated to St. Mary, burned down in 1912. The present structure was built in 1916 and was dedicated to St. Nicholas. Standard Byzantine style reflects the eastern European roots of the church. The early congregation brought three bells and a gospel book from Russia, as well as candelabras and a ceremonial knife from Kiev. Also in keeping with tradition, there are few pews, as congregants stand during service. The

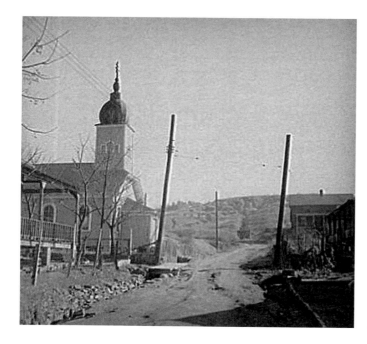

Left: St. Nicholas Russian Orthodox Church, 1930s. *Photo via stnicholasbrookside.org.*

Opposite: St. Nicholas Russian Orthodox Church, 2009. *Photo by Kyle Crider.*

building was improved with exterior brick and interior paneling in the 1960s. The Byzantine-style cupola dome dominates Brookside's skyline.

The Brookside mine was opened in 1886 by the Coalburg Coal and Coke Company. It was purchased one year later by the Sloss Iron and Steel Company as a source of fuel for its blast furnaces in Birmingham. Following the practice of the time, the mined coal was processed into coke in rows of beehive ovens banked into the hillside below the mine opening. An early type of oven that got its name from its domed shape, the beehive oven was in common use in the Americas and Europe from the Middle Ages to the advent of the gas and electric ovens. They were used in industry before the Industrial Revolution in such applications as making tiles and pots and turning coal into coke.

In 1897, a Robinson-Ramsey coal washer was installed, increasing the efficiency of coke burning and therefore the overall efficiency of the mine. Other advanced equipment was also installed at Brookside, placing it at the forefront of mining technology in the Birmingham District at the turn of the twentieth century.

By 1910, the coal mining community of Brookside had a population of 700 (as of the 2010 census, that number was 1,363), the majority of them Slovaks and eastern Europeans. These proud immigrants brought with them

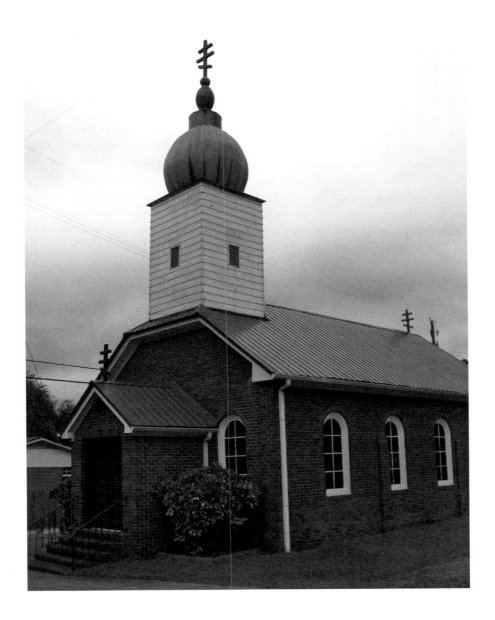

their Old World customs and beliefs. They did, however, learn to enjoy modern conveniences. The town offered an ice plant, two movie theaters, three or four doctors, two drugstores and a blacksmith.

The 1920 Alabama coal strike, combined with a global depreciation in the coal market, led to a shutdown of the mine. When the strike was settled in

1921, Brookside mine was never reopened. Sloss removed all of the surface works and held on to the mine property. In 1952, Sloss merged with the U.S. Pipe and Foundry Company.

In 1924, Brookside served as one of the settings for the Famous Players-Lasky's 1925 feature film *Coming Through*, which was based on Jack Bethea's novel *Bed Rock*. Silent film stars Thomas Meighan, Lila Lee and Wallace Beery stayed with local families during production. (Famous Players-Lasky's, created in 1916, eventually became Paramount Pictures.)

In May 2003, a series of super cell thunderstorms moved from Mississippi across the northern half of Alabama, bringing with them several tornadoes, wind damage, hail and incredible amounts of rain. The north and northeastern sections of metro Birmingham were hit especially hard. The rainfall from this event was the highest on record, recorded at 10.5 inches in a ten-hour period, with 5.5 inches in a one-hour period. The torrential rains resulted in the highest stage (19.14 feet gage datum) since records began in 1953. These floodwaters inundated local roads, including Highway 79. Flooding was especially intense and devastating in Brookside. The few businesses, as well as the town hall, were completely destroyed.

However, the small Brookside Russian Orthodox congregation perseveres. The St. Nicholas Russian/Slavic Food Festival, held annually, features food and pastries from recipes handed down from those who immigrated to Brookside from western Ukraine and what is now known as Slovakia, as well as from Russian members of the parish. The church also hosts a Russian Beriozka Store for imported gifts and souvenirs and offers tours of the historic temple.

SHELBY IRON COMPANY

*When Shelby Iron Company ended production in 1923, Shelby County,
Alabama, at that time, lost its leading industrial concern. It had operated
exclusively on charcoal fuel, was the largest charcoal iron furnace in the United
States and was the longest operating charcoal furnace in the United States. It was
known as the "Queen of American Charcoal Iron Furnaces."*
—Bobby Joe Seales, president of the Shelby County Historical Society

About the time of the great California Gold Rush in the mid-nineteenth
century, Horace H. Ware, known as the father of iron and steel in
Alabama, began one of the state's greatest iron empires near Columbiana
in Shelby County. His first furnace stack was only thirty feet high and was
limited to about five tons of cold blast iron per day.

By 1860, Ware had established one of the most significant industrial
communities in the state, consisting of a blast furnace, a forge, a foundry, a
school, a church and enough homes to house up to several hundred people.
It also was the site of the first large-scale rolling mill in the state and was the
first to use a new bell and hopper charging system and hot blast stoves.

A rolling mill of ten tons' capacity was erected in 1860. This mill
manufactured merchant iron, and from it, the first cotton ties made in the South
were produced. Later, armor plates were made, with some of this material
going into the building of Confederate gunboats *Tennessee* and *Merrimac*.

During the Civil War, practically all the output of pig iron, bars and
armor plates was sold to the Confederate government, and in order to secure

a maximum tonnage, enlisted men from the Confederate army were sent to the plant to assist in operation.

In the early 1860s, with the Civil War looming, Ware sold a majority interest in the company to fund the construction of a second furnace and upgrade the entire operation, according to Jerry Willis, member of the Historic Shelby Association. He brought the workforce from about seventy people to nearly five hundred.

Ware was elected to the board of directors but played a minor role in the company during the war. A.T. Jones was elected president, and under him, the company added a larger furnace, obtained a rail line connecting the company to Columbiana and provided more iron to the Confederate Naval Arsenal in Selma than any other plant in Alabama.

In 1863, a furnace stack was built with capacity of about thirty tons of pig iron per day, which provided aid to the Confederacy during the Civil War. Armor plate for the CSS *Tennessee* and the CSS *Mobile* was rolled here. In the spring of 1864, its operators successfully used coal as a fuel replacement for charcoal, although the practice did not continue. This furnace was in operation until sometime in 1865, when the rolling mill and woodwork of the furnace was burned by Colonel Black of the U.S. Army at the time of Wilson's Raid.

On Friday, August 5, 1864, Admiral Franklin Buchanan and the CSS *Tennessee* steamed away from the protection of the guns of Fort Morgan to engage the fleet of Admiral Farragut in Mobile Bay. The *Tennessee* and its protective covering of armor, provided by Shelby Iron Works, proved a worthy opponent.

The *Tennessee* became the target of the entire Union armada. The ship was rammed numerous times and struck repeatedly by Union gunners. The *Tennessee* was hit by forty to fifty cannon shots, as evidenced by indentations in the armor plating. Of these, only one shot broke through the ship's Shelby iron. The *Tennessee* was forced to surrender after the steering chains and boiler chimney were shot away.

The Shelby plant was rebuilt in 1868. Up to 1862, the company was operated under the corporation name of Shelby County Iron Manufacturing Company, being changed at that time to the Shelby Iron Company. As part of the reconstruction, a new three-story brick commissary was built across from the New Dannemora Hotel (also known as the Shelby Hotel). Upon its completion, the "company store" was opened not only to iron company employees and their families but also to the entire community. The company wanted to help relieve the destitute conditions following the Civil War.

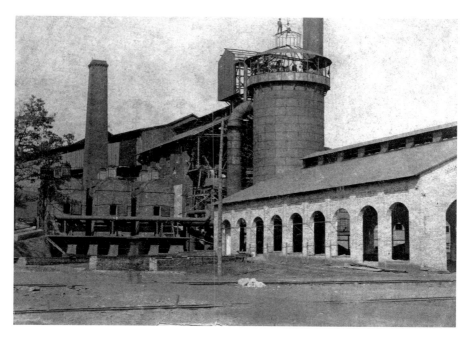

Shelby Iron Works No. 2 Furnace, 1880s. *Bobby Joe Seales, president of the Shelby County Historical Society Inc.*

The well-stocked commissary sold everything from clothing and hardware to coffins. In addition to the store, the building contained iron company offices and a basement laboratory. A large warehouse was located behind the commissary.

The Shelby Iron Company railroad connecting Shelby and Columbiana, about five miles distant, was constructed during the height of the Civil War. In addition to freight, the "Hoodlum," as the train was called, was also a daily passenger service that continued throughout the Iron Company's existence.

In 1873, work was started on a larger furnace, with capacity of about seventy-five tons. This stack was completed in 1875. A second furnace of like capacity was completed in 1889; both of these furnaces were equipped with hot blast stoves for superheating the air blast before it entered the stack and making what is known as "warm blast charcoal pig iron."

In 1882, John Birkenbine, president of the U.S Association of Charcoal Iron Workers, called the Shelby Furnace the "queen of American charcoal blast furnaces." The plant operated through a period of modernizations and expansions until 1923.

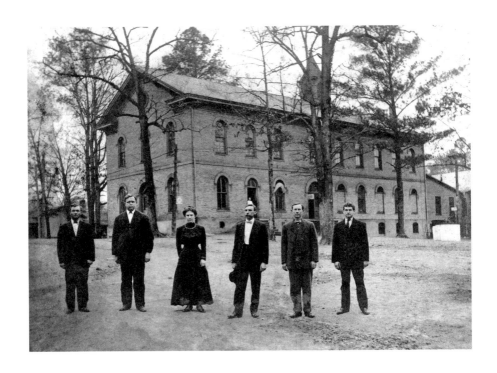

Above: Shelby Iron Works. *Bobby Joe Seales, president of the Shelby County Historical Society Inc.*

Opposite, top: Commissary at Shelby Iron Works, circa 1900. *Bobby Joe Seales, president of the Shelby County Historical Society Inc.*

Opposite, bottom: Train station at Shelby, Alabama, circa 1909, with a train called "Hoodlum" in front. *Bobby Joe Seales, president of the Shelby County Historical Society Inc.*

Captain T.G. Bush of Mobile was made president of the company in 1890, serving in that capacity until his death in 1909, whereupon Mr. Ward W. Jacobs of Hartford, Connecticut, was made president. His term of office extended into 1914, when he was succeeded by Mr. Morris W. Bush of Birmingham.

Although Shelby Iron ceased manufacturing operations in 1923, the company remained in business well into the mid-twentieth century. The depot remained a thriving and important location for Shelby residents. In 1946, the post office still occupied the original 1870 building, located less than one hundred yards from the depot. Mail coming in on the train would be loaded onto carts and pulled to the nearby building. Shelby residents would gather daily to "meet the train" for mail, freight and, of course, to see who was entering or departing town on one of the passenger trains.

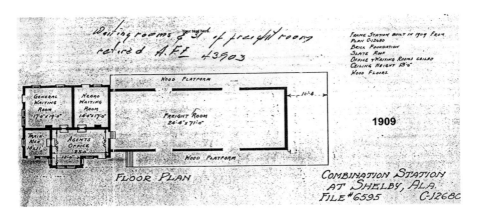

Floor plans for Shelby, Alabama train station, 1909. *Bobby Joe Seales, president of the Shelby County Historical Society Inc.*

In the spring of 1994, Dr. Jack Bergstresser Sr., PhD, and a team of archaeologists from PanAmerican Consultants Inc. began a preliminary archaeological investigation of a portion of the rolling mill at the old Shelby Iron Works. Joining in the dig were students of the University of Alabama at Birmingham and members of the Historic Shelby Association (HSA).

The excavation was funded, in part, by a grant from the Alabama Historical Commission and by partial matching funds by the Historic Shelby Association. Visitors can now visit the remains at the site of Alabama's first rolling mill at the five-acre park at 10268 Shelby County Road 42.

Recently, Buchanan Forest Management of Selma deeded HSA almost thirteen acres located across County Road 42 from the park, where Horace Ware built the company's first furnace in 1846, as a gift to further the group's restoration of what is now Shelby Iron Works Park.

SHELBY HOTEL

Alabama's First Hotel with Running Water and Electricity

The boarding house of the place, the Dannemora, was completed in 1885 at a cost of $10,000, contains about thirty rooms and is one of the best-kept places of the kind in the state.
–Shelby Chronicle, *Trade Issue, December 29, 1887*

The Shelby Hotel, formerly the Dannemora, near Columbiana, was said to be the first in Alabama to have running water and electric lights. It was built in 1863 and was totally destroyed by fire and rebuilt in 1900. The February 8, 1900 *Chronicle* reported:

> On the 31st day of January the Dennemora House was entirely destroyed by fire. When discovered the flames were bursting out of the room of the east wing. An alarm was sounded, and a large number of men soon gathered. By earnest efforts a great deal of furniture was saved, though most of it in a damaged condition. Some silver ware, crockery and carpets were lost. Mr. and Mrs. Wade, who was running the hotel, were the largest losers. Soon after was discovered [a] hose [that] was attached to a hydrant and a powerful stream of water turned on the house occupied by Mr. William Crossett, and though it was but a few feet from the burning building it was saved. The post-office building was also saved by a continuous application of water to the roof. A serious accident occurred during the fire, a falling chimney striking Thomas Bierly, one of the Company's engineers, on the head. Dr. Parker dressed the wound, and

the patient is expected to recover. The new hotel building will be opened this week by Mr. and Mrs. Wade.

The hotel was again struck by fire in 1912, as reported in the February 8, 1912 *People's Advocate*:

On Thursday evening fire was discovered in the roof of the New Dannemora hotel, which came near resulting in total loss of the building. However, the quick work of the well organized firemen of Shelby Iron Co. saved the building after part of the roof had fallen in. Damage from water was considerable, owing to the fact that fire had to be fought entirely from the roof. The New Dannemora is owned and operated by the Shelby Iron Co. and is considered one of the most up-to-date little hotels in the state. The origin of the fire is unknown.

Today, the hotel is a shell of its former self. No longer in use, either as a hotel or residence, the building sits neglected next to Shelby Iron Works Park on Shelby County Highway 42, just west of the intersection of Highway 47. Overgrown with weeds and the victim of years of vandalism, the building—with its rotting boards, collapsing deck and gutted interior—nonetheless remains a beautiful landmark.

The property is closed off but is still visible from the road. The former hotel stands as a reminder of the early days of travel in Alabama. Many have tried to reclaim it, but the current owner of the property is not interested in restoration.

Located on the outskirts of what once was a thriving industrial community, the Shelby Hotel sits next to the former home of Shelby Iron Company. The plant manufactured guns, armor plate and cannonballs for Confederate soldiers before being destroyed by Wilson's raiders during the Civil War. The furnace was repaired and resumed operation after the war.

John Draper III of the *Shelby News-Monitor* spoke with former hotel owner B. Rommell in 1976. "I remember when eight passenger trains would stop in Shelby every day," Rommell told him. "And the people would pile off and come down here to get some of Mrs. Rommell's cooking." Draper wrote:

In front of the buildings is a rusted gas pump with the price of gas reading 19 cents per gallon. The place was abandoned sometime in the mid-fifties. The town of Shelby was deserted well before that, however. The mines shut down in June 1922. It was downhill after that as the entire city depended on the furnace established by Horace Ware in the 1840's for their livelihood, directly or indirectly.

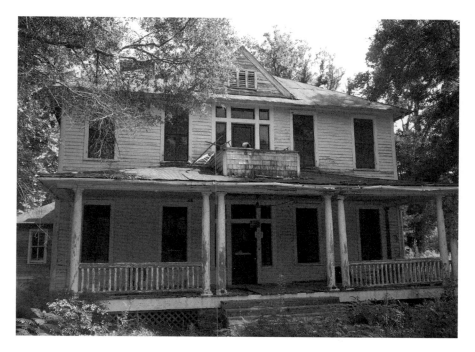

Shelby Hotel, 2012. *Photo by Beverly Crider.*

*The last of the old furnace men in Shelby died in 1936. He was Arnold
Sturdivant, who worked at Shelby for 25 years. Now the town has also died
as most left for Jefferson County and elsewhere.*

Rommell recounted to Draper how Shelby had a good depot when
Birmingham was using an old caboose. "Shelby made some of the best razors
in the world," Rommell said. "Why we made all kinds of things—cooking
utensils, dog irons, boiling kettles, sausage grinders, anything."

The old man also remembered a visit that Teddy Roosevelt made to the
Shelby Hotel:

> *Mr. Roosevelt spent the night right here in this very hotel. He didn't come
> riding up in no fancy car. No sir, he walked.*
>
> [B. Rommell] *came to Shelby some 56 years ago and if Mrs.
> Rommell had lived, would have been married 55 years Christmas Day.
> "She was the best cook in the county," he says quietly and you can tell
> the hurt was deep.*

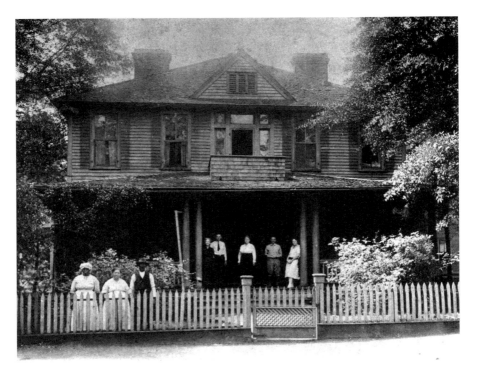

Shelby Hotel, circa 1901. *Bobby Joe Seales, president of the Shelby County Historical Society Inc.*

There is a moment of silence that is uncomfortable until Tom says he would like to see some of the rooms. This white-haired man is on his feet in a twinkle and heads toward the door calling us to follow.

We step into a huge dining room and it is cold. The high ceiling probably makes for cool summers but it's a cold place in the winter. A long hall runs most of the length of the building and we start up the stairs to the guest room.

The bed is large and old and you can feel the elegance that once surrounded the room and its occupants. Now the plaster is cracking and chipped and the rug worn.

Rommell continues our tour of the many rooms and we come to a closet filled with iron works. "All this was made just across the road there." He shows us oxen shoes and other small iron products. Along a mantle are rocks of different types.

Being an "A" student of Dr. Connell's geology class I glance over his collection and start when I notice one small rock has a slight spot of shiny

metal. It looks like pyrite, fool's gold, to me, but I've never seen any real gold in a rock before.

"It's real," Rommell says. "Not enough to do anything with—just a trace."

He goes down the shelf naming mica, dolomite, lead, and others. And he's right on each one. His knowledge prompts me to wonder about his education so I ask.

"Son, I barely finished the 9th grade."

A running commentary of current events and an understanding of almost anything has been evident in our time spent with Rommell. His education is obviously one of experience.

We are just about through with our tour when he calls to one last room. The big door is locked and he shuffles to find the key. Inside is a high, large bed with a spotless white bedspread. In the center sits a delicate wedding doll. The bed is heavy and the black wood shiny even now."

"This is a special bed," he says quietly. "Mrs. Rommell made it up and it hasn't been touched since. She made that Bride doll too. This bed is over 200 years old. I found it a long time ago and cut all the old wood off. This is hand-finished and polished for her," he mumbles as he runs his hand over the fine wood.

Then his mood changes and he gets a smile on his face. "I only rented this room to special people—honeymooners." You can see he takes delight in his memories. "Yep, this is the Honeymoon Bed. Many a couple has spent their first night here."

Tom and I look at the bed in a different light but Rommell gets ready to move-on. He is still spry and as he leads us down to the porch we have to double-time to stay with Tiny and him.

On the front porch is one of those swings like your grandmother always had at her house. The kind your little brother would fall out of if you swung too high and your mom would get mad because you cracked his skull.

We sat for a minute as dusk crept into the sky. Across the road is the ironworks. You can let your mind work and hear wagons at the furnace, the howl of a steam engine down at the tracks, and easy conversation on warm, lazy afternoons.

It's nice to imagine just good things and good times.

SHELBY SPRINGS RESORT

Of summer resorts there are almost as many varieties as there are resorts;
so to enumerate them is akin to impossible. However, to the quiet, homelike,
family class, Shelby Springs properly belongs, and as such, for beauty of site,
healthfulness of location, excellence of water, and all that lavish nature can
accomplish to bring about loveliness, comfort, a freedom from malaria and the
countless other ills that frequently beset springs, it is beyond comparison, on an
unpretentious mild scale, the best of all I have ever seen.

–Selma Times, *1882*

Shelby Springs Resort, which was located between Calera and Columbiana, was central Alabama's most renowned resort. People came from miles around to visit the area's six spring-fed pools for healing and relaxation. Legend has it that Native Americans were the first to enjoy the springs, but the first official mention of Shelby Springs was an 1839 Montgomery advertisement by John S. Washington. The resort consisted of only a few cabins at that time, but the springs were already famous, as evidenced by the ad: "The medicinal qualities, together with the locality of these Springs are too well known to need comment."

The completion in 1855 of the East Tennessee, Virginia & Georgia Railroad to Shelby Springs encouraged investors to build a two-story hotel with about thirty rooms and several cabins on the property. The hotel was L-shaped, and a large porch encircled both floors. A platform was built at the train stop, and visitors would simply walk about one hundred yards to

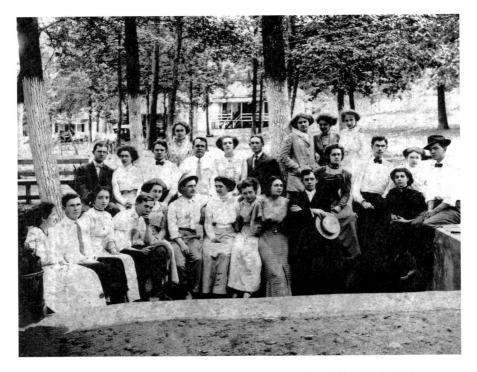

Shelby Springs Resort. *Bobby Joe Seales, president of the Shelby County Historical Society Inc.*

the resort. Large oak and mulberry trees, home to many songbirds, lined the pathways to the hotel, cottages and the mineral water pools.

Shelby Springs, which included about 2,700 acres, was next leased by J.I. Norris of Selma in 1856. In 1862, the resort was taken over by the Confederacy and turned into Camp Winn. In 1863, it was used as a long-term hospital facility to rehabilitate soldiers. Several nuns from the Sisters of Mercy were among the staff that managed the hospital.

The nuns were originally from Boston but were sent to Vicksburg, Mississippi, in 1860 to establish a Catholic school. After the Civil War began, the nuns ministered to sick and injured soldiers at several hospitals in Mississippi before making their way to Shelby Springs.

By early 1864, the hotel had been made into a general hospital and housed a large staff of medical personnel. Those who did not survive their injuries were buried in a nearby cemetery on a hill just above the hospital. On October 24, 2004, the Shelby County Historical Society held a public dedication of the Historical Cemetery Roadside Memorial Marker placed in honor of the burial ground.

At the end of the war, Norris resumed operation of the resort as a popular travel destination, and in 1881, he sold it to Hope Baker and his wife, Mary. An article published in an 1882 issue of the *Selma Times* described the editor's visit to Shelby Springs:

The Selmian alighting at the little station, on looking around on the gathered assemblage of dainty women in white, hordes of children and sunburned men, for there is ever a crowd down to greet and bid farewell to every train, would imagined himself back in his native place, so familiar are all the faces. A short walk of perhaps a hundred yards beneath the grateful shade of wide-spreading mulberry trees covered with fruit and bearing in their branches numberless gaudy-hued, twittering songsters, brings one to the hotel, which is on the edge of a large grove of gigantic oaks that rear their stately heads far skywards in the little valley wherein are located the springs. The hotel is much better than I had expected to find. It is much better than it was. It can and will be made better than it is. The table is well supplied with all seasonable eatables and the meals are served in good style. A hearty appetite is the delightful possession of every visitor to this place, and prompt responses to the different meal bells, and a lengthy stay at the table are noticeable results, that have as prime causes copious and frequent draughts of health-giving waters, an abundance of exercise and sleep, and good, bracing air to breathe.

About the confines of the grove at regular intervals are placed cottages, glistening in newly taken coats of white wash and looking most attractive and bower-like, with the dense, dark green foliage as a background, and the greenest and most inviting carpets of grass everywhere about. A rather large brook of clear water, that rambles on by mossy banks o'er pebbly beds, takes its musical way through the center of the valley, and adds greatly to the beauty of the woodland scene. The springs are six in number and are varied in quantity, quality, and analysis, viz: three sulphur, one limestone, and two chalybeate. In the hotel yard is an excellent freestone well, the icy waters from which are not much used, since to quaff in health with every drink of mineral spring water seems the intention of visitors, and their ideas apparently lean towards the belief that the more water they consume the more health they will acquire.

Shelby as has been said before is essentially a family resort. It is a great place for children, and the sickliest of youngsters begin to improve almost as soon as arriving there. To the seeker after extreme gayety; to the miss in search of extensive and exciting flirtations; to the man in quest of a game

of chance; to the bobby youth whose ambition soars no higher than a spike-tail coat and a ballroom conquest; to the fashionable mother with an eye on her daughter's matrimonial prospect, Shelby would indeed be dull; but to the person of either sex or any age whose summer vacation is wanted to build up his or her constitution; to entice robust health to reign where enervation and sickness have before held death-inviting sway; to the over-worked business man, or others who need complete rest; to the lover of delightful surroundings, improving society and amusements of a not exciting variety; to the admirer of the beauties of nature, and to one long round of lazy delight—Shelby Springs is the haven looked for. Early hours are kept by all the families, the children in particular vieing with each other and his majesty, Old Sol, in seeing which can be stirring first. The damp cool air of night has scarcely been dispelled by the blush of morning, the dew still lies in sparkling beads on the emerald carpet of earth, when the first bell, the dressing bell, rings in the hotel. That its inviting summons is obeyed is proven when a short time after the breakfast bell peals out, and the almost simultaneous opening of room and cottage doors proclaims the hungry procession's starting. The same promptness is evinced at dinner and at supper an equally pleasing state of affairs exists. No unusual attempt at dressing is made. In the morning the ladies without exception wear bewitching white costumes, beautiful in their make-up and simplicity. At dinner a trifle more "agony" is put [on], and at supper thicker garments, for the evenings are remarkable cool, such as bright-colored plated waists with white dresses, are donned with a result absolutely charming. Since in a few lines above the early-to-rise circumstances have been described, the early-to-bed portion may be unnecessary to mention. However it may be proper to state that half-past nine or ten at the latest sees the place shrouded in darkness and given over to the chirping of crickets and the meanderings of sundry large watch dogs about the premises.

Of the amusements croquet takes first place, and the splendid grounds are never without contestants. Young and old participate in the sport and take equal interest in the result of a game. Minds that are busied for eight or nine long months of the year in studying out the knotty questions of law, marking out political campaigns, and conducting large business transactions of great importance, become as much excited and worked up over the proper direction given a croquetted ball as in the most engrossing questions of their various callings. The boys play base ball at all hours of the day, the little girls with their dolls and pets while away the hours most contented, while their loving mothers visit each other continually and discuss new dresses, possible and probable marriages and other womanly topics ad lib.

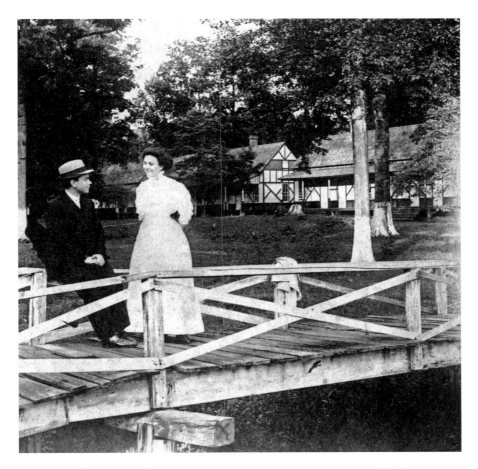

Couple vacationing at the Shelby Springs Resort. *Bobby Joe Seales, president of the Shelby County Historical Society Inc.*

The hotel burned down that same year. It was not until November 17, 1885, that the Bakers took title to the property, which they then leased to Colonel J.M. Dedman of Selma, operator of the St. James Hotel. In 1887, Colonel Dedman built another hotel on the same site as the former one, using the remains of the old foundation for the new building. In addition, he built bathhouses for sulfur baths, which made the health resort more complete.

In May 1887, the Brotherhood of Locomotive Engineers of Selma gave its first annual picnic at Shelby Springs. The *Shelby Chronicle* reported, "After a pleasant run of four hours the Springs were reached, where a large crowd

from the surrounding towns had already assembled to join in the festivities of the day. Col. J.M. Dedman, the genial and hospitable proprietor, had arranged everything in elegant style for the occasion."

The June 13, 1889 edition of the *Shelby Sentinel* noted that the season "promises to be a very pleasant one. The genial proprietor, Mr. H.H. Baker, and his accomplished wife will spare no pains to secure the comfort and pleasure of guests. Besides daily meals, a telegraph station will be established that will give patrons easy and expeditious communication with distant points. The entire premises have been repaired and renovated, and in their new coat of paint and whitewash, Shelby Springs, with its natural pleasing scenic beauties, presents an attractive appearance."

By an act approved by the legislature on February 16, 1892, the proprietor of Shelby Springs was permitted to sell spirituous vinous or malt liquors to his guests or boarders from June 1 until the first of November each year. Hope Baker again took over the management of the hotel that year and advertised that his culinary department would be unexcelled and that the services of experienced physicians had been secured for the sick.

Additional sleeping apartments in the hotel were provided. An elegant dining room that measured sixty-seven by thirty-five feet was built; a billiard room, a bowling alley, lawn tennis and a game room were added; and several new cottages were constructed. A full-time string band was engaged to entertain the guests. The buildings were lit with gas manufactured locally, and the grounds were lit with lamps placed at intervals.

During the latter part of 1896, the hotel burned. Baker, following the destruction of the second hotel, leased the property to Ed Booker of Uniontown. Mr. Booker constructed another dining room and dance hall to accommodate the guests who lived in the cottages. For the next few years, guests at the springs were dependent on cottages for sleeping accommodations.

After the death of Hope Baker, Mrs. Baker married M.M. McMahon. In 1905, she built another hotel on the same foundation that had served the two former buildings. She took over management of the resort in 1906 and provided the following description in a brochure:

> *Twelve acres of campus—the most beautiful in the State, shaded by hundreds of mammoth oak and spreading beech trees—just the place for the children to romp and play. Large crowds of pleasure and health-seekers attend this delightful watering place; belles and beaux here meet for lovemaking, and many a duo of hearts have become one in this sylvan glade…*

These wonderful springs have been celebrated for generations for their curative and cleansing properties, and are known to have cured innumerable cases of chronic stomach and bowel troubles, and diseases of the kidneys, bladder and digestive organs. They are also most salutary in all female complaints. It is not punishment to drink them, as they are all mild and pleasant, cool and palatable, almost as sparkling as champagne.

In an enclosed park of 10 acres are located a comfortable hotel and a large number of cottages, with a capacity for 300 guests...That tired feeling cannot exist at Shelby. No insomnia there, nature's sweet restorative, balmy sleep, an all devouring appetite, rest and healthful recreation and the healing waters of Shelby will make you weigh more, feel better and will be far less expensive than a course of medicine.

One fine Saturday morning in 1905, members of the Birmingham Auto Club (there were about fifteen cars in the city at that time) gathered in front of the Athletic Club at 11:00 a.m. and set off for Shelby Springs. They took the Green Springs route out of Birmingham to Calera. All drivers wore goggles and dusters because of all the dust. By the time they reached Calera, Richard Massey, founder of the Massey Business College in Birmingham, had decided that the idea was not such a great one after all. He put his car on the train for the trip back to Birmingham. The remaining drivers carried on to Shelby Springs, arriving there at 8:30 p.m.

The hotel at Shelby Springs was destroyed by fire in 1910. The resort, following the fire, was leased to W.J. Lloyd of Washington, D.C. Cottages were again used by guests. The dining room and kitchen, which were undamaged by the fire, were modernized.

In 1912, the property was purchased by J. Ray McMillan. He rented cottages to guests and operated the dining room. In 1915, Shelby Springs was closed permanently as a summer resort. The McMillan family occupied the property as their home until 1926, when it was sold to Clyde H. Nelson of Birmingham and associates for the proposed site of the Yamakita Club.

Mr. Nelson laid out an eighteen-hole golf course, built a magnificent concrete swimming pool and landscaped the grounds. A foundation was laid for a brick hotel and clubhouse to contain three hundred rooms, but the work on these buildings was never completed.

In 1938, Captain John Reid Irby, a prominent retired businessman, took title to the property and built a large colonial home near the springs. He enclosed the spring property but piped the mineral waters to the fence line

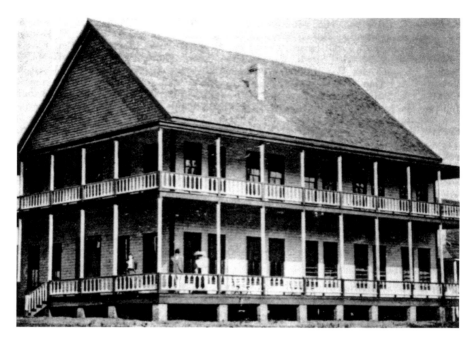

Shelby Springs Hotel. *Bobby Joe Seales, president of the Shelby County Historical Society Inc.*

so that the people in the vicinity could use the water. The original deed stipulated that the water could never be removed from public use.

Following the death of Captain Irby, the property at the intersection of Alabama 25 and Shelby County 42 was purchased in 1944 by Howard Hall of Birmingham for use as a summer home and cattle farm. Current owners Joe and Carolyn Dorris bought the home in 1998. Only one of the original cottages stands on the property, but plenty of reminders still remain from the resort's heyday.

The foundation of the old hotel still stands behind the current home, as do the statues surrounding the springs. In his article about the resort, a former *Selma Times* editor wrote a description that serves as a fitting memorial: "To the quiet, homelike, family class, Shelby Springs properly belongs, and as such, for beauty of site, healthfulness of location, excellence of water, and all that lavish nature can accomplish to bring about loveliness, comfort…it is beyond comparison."

BIRMINGHAM TERMINAL STATION

It has been called a monstrosity, a mosque, a mausoleum, a civic disgrace, a local landmark. It is old, it is dingy. These things it could have survived. What it could not was the decline in railway passenger traffic. Because of this, the city's 63-year old rail terminal is on its death bed.
—Birmingham News, *January 13, 1969*

When it was opened in 1909, Terminal Station was hailed as "the fulfillment of a desire long cherished by the citizens of Birmingham." It was set apart from other stations of its time by its grand design, garnering praise in architectural journals across the country. *American Architect* magazine in 1909 called the terminal "the most extensive of the stations so far built in the South."

Unique in many ways, it was a powerful, sprawling building. Two 130-foot towers topped the north and south wings. The central waiting room covered 7,600 square feet and was topped by a central dome 64 feet in diameter, covered in intricate tile work and featuring a skylight of ornamental glass. No one can accurately estimate the millions who passed through its doors during its years of operation.

Built for the then remarkable sum of $3.0 million, Terminal Station opened as a replacement for an older Union Station. It's interesting to note that 7.32 acres of property on which the terminal sat were placed on the real estate market in 2011 for almost the exact same amount (an asking price of $2.7 million).

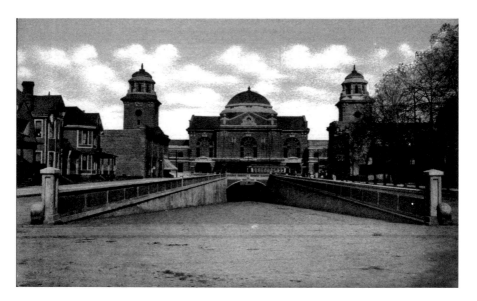

Birmingham Terminal Station and Subway prior to installation of the "Magic City" sign. *Post Card Exchange, Birmingham, Alabama.*

Birmingham Terminal Station and Subway with iconic "Magic City" sign, postmarked 1948. *E.C. Cropp Company, Milwaukee, Wisconsin.*

Covering ten square blocks, its freestanding dome was flanked by twin towers. A magnificent example of Byzantine- and Turkish-style architecture, the terminal served six railroads—all of those passing through the city except for the Louisville and Nashville and the Atlantic Coast Line—as well as the U.S. Post Office's mail facility and Railway Express Agency.

In 1943, the station got a $500,000 renovation that included sandblasting, new paint and new interior fixtures. During this period, rail traffic peaked at fifty-four trains per day. Even after the increased traffic brought about during World War II, the terminal continued to handle forty-two daily train departures through much of the 1950s.

"As a little girl I can remember that beautiful, wonderful place when I traveled with my grandparents," recalled Birmingham resident Janice Bradley. "The shiny marble floors and the wondrous ceiling along with the hustle and bustle of those big trains moving in and out, but the sound of the conductor yelling 'all aboard' is a memory that is still with me today."

In 1926, a large electric sign was constructed outside the station. A gift of E.M. Elliot, the sign read, "Welcome to Birmingham, the Magic City." Later, it was decided that the sign had too much of a "small-town feel," so it was changed to read simply, "Birmingham, the Magic City."

By 1951, the sign had deteriorated so badly that the city's building inspector was calling for its renovation or removal. The framework had corroded due to lack of paint, and the wiring was in need of replacing. It was estimated that restoration would cost $2,500 to $3,000. Commissioner of Public Works Jimmy Morgan opposed restoring the sign because by then more travelers were arriving in Birmingham by plane or car than by train. His counterproposal was to create smaller welcome signs at the airport and main highways. The money was not raised, however, and the sign was torn down in 1952.

In 2010, Birmingham mayor William Bell instructed public works personnel to follow up on leads that parts of the sign remained in storage. A search of city-owned warehouses revealed nothing. It is most likely that the sign was sold for scrap at the time it was dismantled.

More than fifty years after it last stood as part of the Birmingham skyline, the sign remains one of the city's most recognized historical images and is the most requested photo from the library, according to Birmingham Public Library archivist James Baggett.

SEGREGATION

Built when segregation was still the law of Alabama, Terminal Station had separate waiting rooms for black and white patrons. In November 1955, the Interstate Commerce Commission banned segregation among interstate passengers. Despite this ruling, the Alabama Public Service Commission, on February 8, 1956, issued General Order No. T-21, stating that rail stations and depots had to have separate waiting rooms clearly labeled "White Waiting Room" and "Colored Waiting Room." At Terminal Station, the rooms were labeled "Colored Intrastate Passengers Waiting Room" and "Waiting Room Interstate and White Intrastate Passengers."

On December 17, 1956, Carl and Alexinia Baldwin, a black couple holding round-trip tickets to Milwaukee, sat in the white waiting room while waiting for their train. Birmingham police officers arrested the couple on charges of disorderly conduct when they refused to move to the "Colored Waiting Room."

On January 25, 1957, the Baldwins brought a lawsuit against the Birmingham City Commission, the Alabama Public Service Commission (APSC) and the Birmingham Terminal Company in U.S. District Court to desegregate the waiting rooms in Terminal Station, charging that the state railroad waiting room law was unconstitutional. On February 25, while action in the federal court was still pending, the city dropped the disorderly conduct charges against the Baldwins. Because the city dropped the charges, U.S. District Judge Seybourn H. Lynne dismissed the federal suit on March 4, saying that a mistake had been made and that the case was therefore hypothetical.

As a result of Judge Lynne's ruling, Reverend Fred Shuttlesworth, a prominent black Birmingham civil rights activist, announced to the media his intention to sit in the white waiting room. On March 6, when Shuttlesworth and his wife, Ruby, arrived at Terminal Station, they were confronted by a group of white men. The Shuttleworths attempted to enter through a different door and were pushed back by a different white man. At this point, Birmingham police cleared a path, allowing the couple to purchase tickets and sit in the white waiting room for about one and a half hours, awaiting their train to Atlanta. Police guarded them the entire time as the group of white men grew to a crowd of about one hundred.

The Baldwins' case was repeatedly appealed, and ultimately, the Court of Appeals declared in February 1961 that segregation at the station was

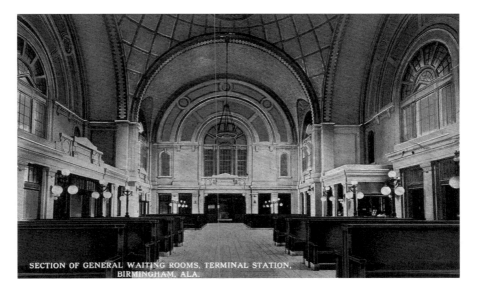

Section of the general waiting rooms, Birmingham Terminal Station. *Post Card Exchange, Birmingham, Alabama.*

"in violation of the Fourteenth Amendment and the civil rights act" and ordered the district court to suspend those practices.

DECLINE

"The death of Terminal Station began as early as 1958," according to a 1969 issue of the *Birmingham News.* "Passenger trains were in decline. Birmingham's dream had come to be referred to as 'a giant in a coma from which it will never awake.'"

As automobile ownership increased and air travel gained popularity, rail travel declined. By 1960, only twenty-six trains per day went through Terminal Station. As early as 1962, the site was being recommended for redevelopment. Mayor Art Hanes and the Birmingham City Commission offered the property to the U.S. Postal Service for a proposed $10 million bulk mail handling facility, but postal officials felt that relocating track and train facilities would be too expensive. By the beginning of 1969, only seven trains still served the station daily.

Fifth Avenue Tunnel, all that remains of the Terminal Station subway, 2013. *Photo by Beverly Crider.*

During this period, the U.S. Social Security Administration announced plans to build a consolidated service center in downtown Birmingham. The sole owner of the station by that time was Southern Railroad. William Engel of Engel Realty presented the railroad with a $10 million plan that called for demolition of the station and a smaller station to be built along with the Social Security building, two additional office buildings and a large motel. These plans were not revealed publicly until shortly before Engel sought permission to demolish the station.

On June 30, 1969, the Alabama Public Service Commission approved demolition of the station, despite objections by groups such as the Heart of Dixie Railroad Society and the Women's Committee of 100. The Public Service Commission stated that it only had authority to consider the necessity and convenience of the traveling public, which the station no longer served. Demolition by the T.M. Burgin Demolition Company began on September 22. The main terminal was maintained until the smaller terminal building was built nearby. By December, the station's land had been completely cleared.

After the destruction of the Birmingham landmark, the Social Security Administration decided to build elsewhere. With the Terminal Station gone, however, the city saw the answer to a different problem: where to route the proposed Red Mountain Expressway. Original plans for the highway called for the destruction of 100 to 150 units of the Central City Housing Project. The route could now be altered to run through the former Terminal Station

property. That portion of the expressway, however, was not built until the late 1980s.

ARCHITECTURE

Architect P. Thornton Marye described his work on the terminal in a 1909 edition of the *American Architect*:

> *The Birmingham Terminal Station, which was opened to the public on April 6, is the most extensive of the stations so far built in the South. It is used jointly by the Southern, Seaboard, Central of Georgia, Alabama Great Southern, Frisco System and Illinois Central.*
>
> *The closing of Fifth Avenue by the tracks and the building made it necessary to make a subway of it 56 feet in width, with head room of 17 feet under the building and tracks. Fifth Avenue was widened from 25th to 27th Street, leaving a double driveway on grade from 25th to a plaza over the subway at 26th St. Two stairways connect the plaza and subway.*
>
> *The building faces the plaza and 6th St., with its axis on the center of 5th Avenue. The waiting rooms are located in the center, the baggage and mail rooms in the south wing and express rooms in the north wing. A passenger "midway," 40 x 271 feet, is located between the tracks and the central part of the station building, and trucking platforms 20 feet wide are located between the tracks and the baggage and express wings of the building, with cross-overs for trucks connecting the platforms at the north and south ends of the train shed. A wide stairway connects the midway with the 5th Avenue subway.*
>
> *The train shed, constructed of reinforced concrete, is 780 feet long, covering two platforms and four tracks, and 630 feet long, covering three platforms and six tracks. The total width is 210 feet over five platforms 19 feet 6 inches each in width, and two single and eight pairs of tracks.*
>
> *In the center of the station building is located the general waiting room with smoking room, barber shop, ladies' waiting room, news and refreshment stands, telegraph and telephone booths, ticket office and information bureau adjoining.*
>
> *To the left of the north concourse, as you enter, are located the lunch room, dining room, service rooms, kitchen, etc. The lunch room, designed*

and thoroughly equipped for quick service, is reached from both the concourse and midway, the dining room being located in the front as far as possible from the noise of trains.

To the right as you enter the south concourse is located the waiting room for colored people, with the smoking room, woman's retiring room, toilet rooms and lunch counter adjoining. The ticket office is located between the south concourse and the main waiting room, so as to be accessible to both white and colored passengers. The checking space of the baggage room [was also] equally accessible to both races.

The necessity for separate accommodations for the two races, which is now required by statutes in most of the Southern States, creates a problem not met with in the planning of stations in other sections of the country. The accommodations for the colored race are required to be equal in every respect to those for the white people, and the economy of operation requires that they be so located as to be accessible to the ticket office, baggage rooms, etc., and prompt service rendered without material increase in the operating force of these departments.

The ceiling of the main waiting room is constructed of four barrel vaults intersecting with a central dome 64 feet in diameter, which, together with the outer dome, are all of terra-cotta tile of the Gaustavino construction, covered with terra-cotta roofing tiles. Cornices and flashing are of copper, and all skylights are of copper glazed with wired glass.

The power plant consists of two 200-horsepower Sterling water tube boilers and three Russell engines direct connected with Western electric generators of three-wire type; two units of 125 kilowatts and one unit of 50 kilowatts. This plant furnished heat for the building by means of an Evans-Almirall hot-water system, and direct steam for heating cars standing in the train shed. The station building, train sheds, yards and approaches are all lighted from this plant.

All departments of the station are connected by telephone.

BIRMINGHAM'S QUINLAN CASTLE

*Quinlan Castle looks like a bad joke or the entrance to the world's shoddiest
amusement park; bizarre medieval façade wrapped tight around squalid
little apartments, cockroaches and one whole side of the building condemned,
abandoned to the homeless people who have broken in through first-floor windows
and torn up the carpet for their smoky, toxic fires.*
—from Threshold, *by Caitlín R. Kiernan, author and former Birmingham resident*

Were Communists gathering national secrets via a spy headquarters in
Birmingham? Were the "Reds" about to infiltrate our nation through
a building located in the Heart of Dixie? What was really going on inside
this strange castle standing guard over Birmingham's Southside?

Those of us who grew up in the Magic City have probably grown
accustomed to the site of Quinlan Castle, tucking it away in the back of
our minds as just another of Birmingham's landmarks. Visitors to our city
probably lift an eyebrow if they spot it among the amalgam of buildings now
populating the city. But just what is this medieval fortress?

Basically, it's just a "crazy, quirky, wonderful piece of architecture" that
was built to make a statement on Birmingham's skyline, according to the
Birmingham Historical Society.

Quinlan Castle was built in 1927 to look like a medieval fortress, complete
with turrets at each corner. The name of the building was taken from
Quinlan Avenue, the former name of Ninth Avenue South, which honored
Bishop Quinlan of the Catholic Diocese of Mobile. Quinlan purchased the

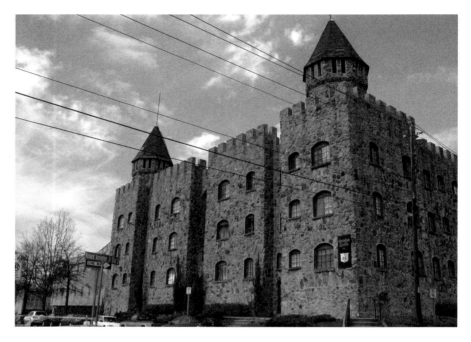

Quinlan Castle, 2005. *Photo by Beverly Crider.*

hilltop and surrounding property as a potential site for Birmingham's first Catholic church.

In the early part of the twentieth century, apartment complexes, where unmarried men and women lived in proximity to one another, were considered risqué and scandalous in the Deep South. And given the rather odd exterior of the building, it provided plenty of fodder for the rumor mills.

Reportedly, in 1940 (a decade before the Communist witch hunts spearheaded by Senator Joe McCarthy), Birmingham police led a raid on Quinlan Castle because it was rumored to be a Communist Party headquarters. Robert Hall, the secretary of the Communist Party in Birmingham at the time, apparently lived in the complex. Police found little of interest besides a letter from a Tennessee Valley Authority employee suggesting Communist activities in that agency. Still, the negative publicity led the owners to change the name to the Royal Arms Apartments.

In 1984, Quinlan Castle was added to the National Register of Historic Places, and by 1998, the structure was added to the "Places in Peril" list of the Alabama Historical Commission and the Alabama Trust for Historic Preservation.

"I lived at Quinlan Castle when I moved to Birmingham around the mid-1990s," recalled John E. Hurley, Belk/Lancome sales and training coordinator.

They had been "gutted" or cleaned up a bit. There may have been about six others that occupied the Castle. I had no idea that prior to my moving in, it was seedy or shady.

The gates to the front and back were always locked and to gain access, you needed a key. I remember as you entered the gates into the courtyard that there were always flowers blooming. There was a place to do laundry and you were able to get to the top of the castle where we would lay out in the sun. I remember I could park my jeep right in front of the castle and walk in. No long walks. Good memories.

Marty Gordon, an artist and former minister, moved to Birmingham in 1996. He had just completed seminary and was joining a new drama touring group called Face to Face. A friend drove him around the downtown area one day to help him find a place to live. When they passed Quinlan Castle, he said that he fell in love with it immediately:

We copied the number down, I called and, before I knew it, I was a resident of the castle. It wasn't the most comfortable apartment I've ever lived in. The AC was one of those huge, clunky hotel window units. It consumed electricity at an alarming rate so I went without that summer. Yes, it was hot! Basically all I used it for was decoration. I bought some of those alphabet magnets and spelled out "A man's home is his castle" with them on the side of the unit.

In the winter, the walls in my bedroom sweat so bad that water dripped down the walls. When they painted the bathroom, they used the wrong kind of paint and it started to peel after a few weeks of use. But, all in all, it was an okay place. It was actually perfect for a bohemian like myself. It was near the Five Points area of Birmingham, a neighborhood bustling with restaurants, shops and clubs. The apartment and its surroundings had character. And I could tell people I lived in a castle.

The castle was in pretty good shape when I moved in. They had renovated it into lower-income housing. I found out that before that time, its nickname was Crack Castle due to the seedy patrons who haunted its halls. Security gates had been installed so it was much better when I lived there. I understand it's sitting empty now, and the city is trying to decide what to do with it. I wish I were a rich man. I'd buy it and do something with it. It deserves to exist and have a purpose.

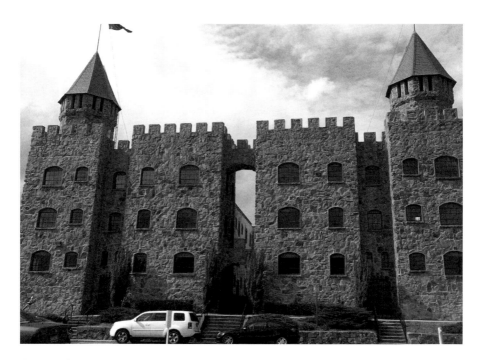

Quinlan Castle, 2012. *Photo by Beverly Crider.*

In response to several proposals to demolish the building, the *Birmingham Business Journal* published a 1999 editorial that noted, "While Quinlan Castle is no prize in its current state, and even though it may have been an architectural oddity to begin with, razing it would leave a noticeable hole in the fabric of Birmingham."

Southern Research Institute bought Quinlan from the City of Birmingham in August 2008 and promised to try to rehabilitate the shell of the medieval-style structure. Under its agreement with the city, SRI had up to ten years to find a use for the property.

The rumors continue about the delightfully odd spot on Birmingham's skyline. A blog dedicated to the popular book and television series *True Blood* recently posed the question, "Think you've staked out a real vampire nest?" You guessed it: Quinlan made the list. A blog follower who goes by the name "Lividity" submitted Quinlan Castle. In the tongue-in-cheek response, the reason it was suspected of harboring vampires is that it is located within walking distance of the UAB Blood Bank.

RUFFNER MOUNTAIN NATURE PRESERVE

The loss of several Birmingham landmarks in years prior and the awakening of environmentalism in Alabama soon created a coalition of individuals and groups that decided Ruffner was too precious for the community to lose.
—Kathy Stiles Freeland, founder of the Ruffner Mountain Nature Coalition

Located on the slopes of Red Mountain within sight of downtown Birmingham, Ruffner Mountain Nature Preserve, covering more than one thousand acres, is the nation's second-largest urban nature preserve. In the early days of Birmingham, this area was one of the most important sources of iron ore and limestone, two of the ingredients needed to make iron. Today, the mountain is honeycombed with abandoned mines, old rail beds and the foundations of mining buildings.

The area is named for William Henry Ruffner, a noted educator and geologist from Virginia who in 1882 mapped the geologic features of the mountain, including the iron ore and other resources valued by iron and steel companies. In the late 1880s, Sloss Iron and Steel Company established mining operations on the mountain that ran until 1953.

The Ruffner No. 2 mine (originally part of the Irondale Mines or Upper Sloss Mines) was an ore mine operating from about 1886 to 1953 on the southeastern slopes of Ruffner Mountain to supply the Sloss-Sheffield Steel and Iron Company with red iron ore. The mine's ore crusher and other ruins remain as points of interest in the Ruffner Mountain Nature Preserve.

Ruffner Mine No. 1, 1906. *U.S. Geological Survey.*

The ore mining itself was carried out by contracted workers, usually African Americans working under the direction of white supervisors. In 1892, the miners earned sixty cents per car (about one ton). The miners cut the face with picks, wedges and sometimes explosive charges. They loaded the cars and moved them under their own power to the surface works on tram rails they had laid themselves.

"For decades after iron ore mining and limestone quarrying activities ceased in the 1950s on Ruffner Mountain, generations of South East Lake/ Roebuck children wandered through its forest, climbed an old fire tower on its summit to enjoy a spectacular view and explored the ore mining relics left behind by the mining company," said Kathy Stiles Freeland, founder of the Ruffner Mountain Coalition. "Ruffner Mountain, the last undeveloped portion of the Red Mountain Ridge running through Birmingham, had become an unofficial nature park."

Beginning in the late 1960s, individuals who owned twenty-five acres of the property began drawing up plans for a major apartment development. When the proposed development was announced, the South East Lake

Neighborhood Association members began protesting it and were able to stall the plans. In the meantime, area environmental groups had begun to take notice.

In 1977, the Ruffner Mountain Nature Coalition, a nonprofit conservation organization, was incorporated, and it led the decades-long effort to preserve Ruffner Mountain for use as a nature preserve and environmental education center for the community.

"The coalition was a mix of middle-class residents of the South East Lake and Roebuck communities, environmentalists, educators and wildlife rehabilitation experts," Freeland says. "Many in the community, including some in the environmental community, were not at all sure such a mix of folks without a lot of experience or knowledge about land conservation nor with a source of major wealth, could carry off such a plan—preservation of a one-thousand-plus-acre former mining site in the city limits of Alabama's largest urban population."

Hundreds of people gave money and thousands of hours of volunteer time, wrote letters and appeared at city council meetings to protest its loss and urge its preservation, according to Freeland. The effort soon grabbed the media's attention—the first story about the dream of preserving Ruffner Mountain was front-page news.

"A local neighborhood had to give up what to that point had been an unofficial neighborhood park and open their arms to the wider community as partners to save this special place," Freeland said. "This unique partnership consisted of neighborhood residents, environmental groups, federal and local governments, the corporate landowner of the bulk of the property, other corporations, local and national foundations and a national conservation organization, the Trust for Public Land, and it evolved into a mighty force."

Today, more than one thousand acres of Ruffner Mountain have been acquired, more than twelve miles of nature trails have been created and a three-acre accessible wetland/boardwalk and a ten-thousand-square-foot LEED-certified visitor's center have been constructed. The Tree House (formerly known as the Tree Top Visitor Center), which opened in 2010, is a LEED Gold-certified visitor/educational center sitting high in the tree canopy and featuring a living plant roof and sustainable building materials. LEED (Leadership in Energy and Environmental Design) certification is the recognized standard for measuring building sustainability, according to Michelle Reynolds of the Ruffner Mountain Nature Preserve Board of Directors:

Marker for the Ruffner Mountain Nature Preserve Trail. *Photo via B-Metro.com.*

I am lucky. I live in a neighborhood that is nestled against the side of Ruffner Mountain. I can walk out the door of my house, and in just a few minutes, I can be at Ruffner Mountain Nature Preserve. Once there, it feels like I am far from everything else. For me, the mountain is my re-start button on a stressful day, my social network, my exercise gym, my meditation spot, my backyard. I like to think there is a sort of symbiotic relationship between me and the mountain.

"People are surprised when they come to Ruffner," former Ruffner Mountain employee Marty Schulman said in a 2002 *Black & White* article. Schulman, who leads mountain nature hikes, said, "They have no idea that so much equipment remains (from the mining days). There's a natural curiosity that people have for all this industrial stuff around here."

Schulman started exploring the mountain and found mining relics that nobody knew much about. After researching old mining maps and comparing them to what he had found, he developed a good idea of what Birmingham's mining community was like from the late 1800s through the early 1900s.

"The crown jewels are the remnants of the ore crushers," he said. "They look like these monster coffee grinders still standing sentinel out in the middle of the forest."

One area of the trail reveals a hole large enough to bury a truck. It was caused by an explosion that occurred during the 1970s, when the facility was still used to store explosives. One night in June 1975, the dynamite exploded, causing an enormous fireball that could be seen by residents of East Lake. "It's still a mystery why it happened, but it blew people out of bed, shattered windows in Roebuck and broke foundations all around," said Schulman.

Ruffner Mountain Nature Center draws about thirty thousand visitors a year and offers a variety of educational programs. The center offers on-site and outreach programs for K-12 schoolchildren that align with state curriculum standards, and the nature preserve serves as an outdoor classroom and scientific field laboratory for high school and college students.

Ruffner plans to restore a mountaintop fire tower that will give visitors a 360-degree view of Greater Birmingham from an altitude of more than 1,300 feet, the highest point in the city, according to Executive Director Robbie Fearn. The tower, built in 1941 by the Civilian Conservation Corps, has been closed for years. By restoring the tower and making it a recognized part of the Birmingham skyline, Fearn said that they hope to see it become an icon for the city, much like Birmingham's *Vulcan* statue.

The Ruffner fire tower's official name is the Wharton Tower, but it's also called the East Lake Tower. It's listed on the National Historic Lookout Register and is one of 119 fire towers still standing in Alabama, according to the Forest Fire Lookout Association.

The Ruffner staff performed a nature inventory of the property and plugged the results into a model developed by the U.S. Forest Service. According to that model, Ruffner's 268,000 trees provide $471,000 worth of air pollution removal annually. The mountain filters an estimated 100,000 gallons of water per day that recharge Roebuck Springs and Village Creek to the north, with a similar amount draining to Shades Creek in the south.

Kelly Smith Trimble, a writer and editor, moved to the Roebuck Springs neighborhood in 2007, drawn there by the landscape and the proximity to Ruffner, which is only about one mile away from her home. "This land was ravaged by mining during our city's industrial boom, but through the benevolence and dedication of some of its citizens, the land was reclaimed and restored."

BIBLIOGRAPHY

BOOKS

Buchanan, Charles. *Fading Ads of Birmingham.* Charleston, SC: The History Press, 2012.

Cruikshank, George M. *Birmingham and Its Environs.* Chicago: Lewis Publishing, 1920.

DuBose, John Witherspoon. *Jefferson County and Birmingham, Alabama: Historical and Biographical.* Birmingham, AL: Teeple & Smith Publishers, 1887.

Goldsmith, B. West. *The Hawes Horror and Bloody Riot at Birmingham: A Truthful Story.* Birmingham, AL: Caldwell Printing Company, 1888.

Kiernan, Caitlín R. *Threshold.* New York: Roc, an imprint of New American Library, a division of Penguin, 2007.

Ragan, Larry. *True Tales of Birmingham.* Birmingham, AL: Birmingham Historical Society, 1992.

Sulzby, James F., Jr. *Historic Alabama Hotels & Resorts.* Tuscaloosa: University of Alabama Press, 1960.

MAGAZINE AND NEWSPAPER ARTICLES

AL.com. "Birmingham Zoo to Level Monkey Island, Last Original Exhibit." October 10, 2009.

Avondale Sun 10, nos. 19–23 (April–June 1935). Avondale Mills publication.

Baggett, James L. *Birmingham Magazine.* 2006.

Barber, Dean. "Auction Brings No Buyer for Decaying Hotel." *Birmingham News*, September 18, 1987.

Birmingham Business Journal. August 1, 1999.

———. "Glory Days Long Gone for Thomas Jefferson Hotel." July 7, 2002.

———. October 19, 2012.

Birmingham News. "Grandeur Settles into Dust of Fate, Progress." December 19, 1971.

———. July 19, 1981.

———. "Looking Back." October 18, 1959.

———. "Lyric to Open with Pictures." April 24, 1932.

Birmingham News-Age Herald. "Avondale History Colorful." January 27, 1929.

———. "Powell, First Public School in This City Rich in History of Trials of Education." June 17, 1928.

Birmingham Post. "Fifty Years Ago Teachers Called Birmingham School Kids by Number." September 24, 1932.

———. "Henley and Powell Are Firetraps." March 25, 1941.

———. January 17, 1934.

———. "Lyric Is Old Theater, Yet Very Modern." October 17, 1945.

———. "Pioneer Dies at East Lake." August 3, 1935.

Birmingham Post-Herald. May 23, 1964.

———. "Powell Centennial Brings Memories of Days Long Gone." February 21, 1972.

Birmingham Sunday Chronicle. "First Boy Born in Birmingham." September 12, 1886. Transcribed by R.B. Henckell, 1960.

Black, Tommy. "Study to Determine Powell School Fate." *Birmingham News*, November 30, 1980.

Brock, Glenny. "On with the Show." *B-Metro Magazine*, 2011.

Bryant, Joseph D. "Birmingham Neighborhood Arts Group Presents Its Own Ghoulish Event at East Lake Park." AL.com, October 5, 2012.

———. "Bringing Back the 'Magic': The 'Magic City' Sign, That Is." *Birmingham News*, AL.com, November 16, 2010.

———. "Lyric Theatre Restoration Effort Gets $500,000 Boost with Birmingham Contribution." AL.com, n.d.

Carter, Robert. "Progress 2012: Staci Glover, Keeper of Brookside's History." *North Jefferson News*, August 9, 2012.

Cason, Mike. "Birmingham's Highest Point: Ruffner Mountain Planning to Restore Fire Tower for Public Viewing." AL.com, December 24, 2012.

Chronicle. February 8, 1900.

Colburn, Sarah. "Plan Could Make Lyric Theatre Sing." *Birmingham Post-Herald*, June 5, 1998.

Cooper, Lauren B. "Lyric Theater Undergoes EPA Testing for Restoration Project." *Birmingham Business Journal*, April 29, 2011.

Cousins, Catherine. "Resort Trains, Heals Soldiers." *Shelby County Reporter*, March 22, 2010.

Dedman, Christie. "East Lake Arts District Haunted Event Oct. 30." *Birmingham News*, AL.com, October 29, 2011.

Diel, Stan. "Birmingham's Fire-Gutted Powell School to Get New Roof." AL.com, October 10, 2012.

———. "Tom Cosby Leaves BBA for Fundraising Firm, Will Head Lyric Theatre Fundraising." AL.com, October 30, 2012.

Edge, Lynn. "Terminal Station Hailed in 1909 as Desire Fulfilled." *Birmingham News*, July 1969.

Haarbauer, Don Ward. *Metro Magazine*, November 8, 1978.

Harvey, Alec. "Birmingham's Lyric Theatre: As Films Roll, Curtain Rises on Entertainment History." *Birmingham News*, AL.com, September 25, 2010.

Hogberg, Veronica. "Cave Man." *Black & White*, November 21, 2002.

Hoole, W. Stanley. "Ghosts of Birmingham's Morbidly Fascinating and Violent Past." *Weld*, October 27, 2011.

Huebner, Michael. "Birmingham's Lyric Theatre: Heightened Anticipation for Long-Awaited Restoration." *Birmingham News*, AL.com, August 5, 2012.

Jones, Pam. "Brookside: A Wild West Town." *Alabama Heritage Magazine*, no. 85 (Summer 2007).

Kennedy, Harold. "Historic School in Peril of Expressway Routing." *Birmingham News*, July 11, 1974.

Kincey, Robert W. "Early Days at Avondale Recalled." *Birmingham News*, July 6, 1960.

Marye, P. Thornton. "New Terminal Station, Birmingham, Ala." *American Architect*, 1909.

McDowell, Katie. "Looking Back at Shelby Springs." *Shelby Living*, September 11, 2012.

Mendelson, Mitch. "East Lake, Deep Roots Search for Secure Future." *Birmingham Post-Herald*, January 26, 1981.

MyFoxAl.com. "Live Music to Be Performed in Birmingham's Lyric Theater." September 28, 2012.

People's Advocate. February 8, 1912.

Reynolds, Ed. "Six Flags Over Birmingham?" *Black & White.* August 14, 2003.

Richards, Charles. "Overtaken by Time Terminal Awaits Last All-Aboard." *Birmingham News,* January 13, 1969.

Ruisi, Anne. "Historic Avondale Park in Birmingham Reviving Bloom of Youth." *Birmingham News,* February 28, 2011.

Rukpinski, Patrick. "Hotel Once Heralded as City's Crowning Gem." *Birmingham Post-Herald,* July 15, 1981.

Shelby Chronicle. Trade Issue, December 29, 1887.

Shelby News-Monitor. January 22, 1976.

Shelby Sentinel. August 17, 1882.

Shuler, Roger. "What Came Before: Exploring UAB's Past Lives." *UAB Magazine* (Spring 2008).

Shunnarah, Mandy. "Remembering Birmingham's Past: Leer Tower." *Magic City Post,* April 5, 2012.

———. "Remembering May Hawes at Child of the Lake." *Magic City Post,* October 26, 2012.

Spencer, Thomas. "Ruffner Mountain Nature Center Expands Offerings as City Proposes No Funding." AL.com, May 27, 2012.

Timberlin, Michael. "Former Downtown Site of the Birmingham Terminal Station Is Up for Sale." *Birmingham News,* AL.com, February 20, 2011.

———. "Stabilizing Powell School First Step in Potential Restoration." AL.com, October 28, 1011.

Waddle, Chris. "Powell School's Face-Lifting Now Complete." *Birmingham Post-Herald,* August 23, 1969.

Weaver, Emmett. "Lyric Theater Comes to Life." *Birmingham Post-Herald,* November 1979.

WEBSITES AND BLOGS

Birmingham Rewound. www.birminghamrewound.com.

Birmingham 365. www.birmingham365.org.

Brookside. www.brooksidealabama.com.

Burden, Greg. "Bangor Cave." http://bangorcave.webs.com.

Castles of the United States. www.dupontcastle.com/castles/quinlan.

Ellaby, Liz. "The Old Stork: Thomas Boulware Delivered Health Change to Birmingham." 1731 Blog Avenue blog. http: birminghamhistorycenter.wordpress.com/2012/07/05/the-old-stork thomas-boulware-delivered-healthcare-change-to-birmingham.

Encyclopedia of Alabama. www.encyclopediaofalabama.org/face/Home.jsp.

Goldring/Woldenberg Institute of Southern Jewish Life. "Merchants Born of Iron and Steel." Encyclopedia of Southern Jewish Communities. http://isjl.org/history/archive/al/birmingham.html.

Gordon, Marty. "Quinlan Castle." Renzn'tzman blog. http://renzntzman. blogspot.com/2007/03/quinlan-castle.html.

Great American Stations website. www.greatamericanstations.com/ Stations/BHM.

Henckell, R.B. "City Will Celebrate 80 Magic Years of Progress." December 1951. Birmingham Public Library Digital Archives. http://bplonline. cdmhost.com/cdm/singleitem/collection/p4017coll2/id/485/rec/1.

Historic Shelby Association. www.shelbyironworks.com.

History Engine. "Captain O'Brien Gives Birth to Theatre in Birmingham." University of Richmond. http://historyengine.richmond.edu/episodes/ view/5232.

Izaak Walton League of American. www.iwla.org.

Kenrick, John. Information from *History of the Musical Stage 1860s: The Black Crook*. Musicals 101. www.musicals101.com/1860to79.htm.

Light Up the Lyric. www.lightupthelyric.com.

McWhorter, Lynn Price. "Encyclopedia of Alabama." Auburn University. www.encyclopediaofalabama.org/face/Article.jsp?id=h-2141.

Raney, Marilyn, Former Development and Communications Manager at Ruffner Mountain Nature Center. www.encyclopediaofalabama.org/ face/Article.jsp?id=h-3116.

Restoring Birmingham. "Alabama's Historic Lyric Theatre." http://branto. wix.com/lyricfineartstheatre#!history.

Ruffner Mountain Nature Center. www.ruffnermountain.org.

Ruffner Mountain Nature Center, Auburn University, College of Agriculture. www.ag.auburn.edu/auxiliary/grassroots/groups/rmnc.php.

Samford University Library Special Collection. http://library.samford.edu/ about/sc/treasure/2005/ruhama.html.

St. Nicholas Russian Orthodox Church. www.stnicholasbrookside.org.

ffner Mountain Nature Center." http://alabama-
gs-to-do/attractions/ruffner_mountain_nature_

Birmingham-Southern College. http://trekbirmingham.

Wiki. "Possible Vampire Nests." http://truebloodwiki.wetpaint.
page/Possible+Vampire+Nests.
University Archives, University Hospital Historical Collection. http://
www.uab.edu/lister/deptsunits/historical.

OTHER SOURCES

Birmingham Convention and Visitors Bureau.
Birmingham History Center, Birmingham, Alabama.
Gerlach, Gary G. Interment records of the Red Mountain Cemetery, 1888–
1906. Birmingham Public Library, Archives Department, 2004.
Haarbauer, Don Ward. "A Critical History of the Non-Academic Theatre
in Birmingham, Alabama." Vol. 1. PhD diss., University of Wisconsin–
Madison, 1973.
Historic American Buildings Survey. Washington, D.C.: National Park
Service, Department of the Interior.
Historic American Engineering Record. "Ruffner Red Ore Mines." http://
lcweb2.loc.gov/pnp/habshaer/al/al0900/al0962/data/al0962data.pdf.
McCullough, Patricia Cloud "Cush." "Families of Avondale Mills
Group." Facebook. http://www.facebook.com/home.php#!/
groups/154719951211614.
Schneider, David. "Alabama's Most Endangered Sites for 2011." Alabama
Historical Commission, May 25, 1011.
Seales, Bobby Joe. President of the Shelby County Historical Society Inc.

INDEX

ABOUT THE AUTHOR

Beverly Crider is a freelance writer with a background in media relations and web design. Back in "pre-Internet days," she founded the Magic City BBS, a dial-up computer bulletin board system that introduced Alabama to its first online newspaper: the *Birmingham Post-Herald*.

An Alabama native and proud graduate of the University of Alabama, Beverly currently travels the back roads and forgotten haunts of the state in search of material for her blog, "Strange Alabama," on AL.com and on Facebook. When it's time to put pen to paper (or pixel to screen), she's usually surrounded by her five furry children, also known as the "Crider Critters," who provide their own form of inspiration.